IMAGES
of America

ROCHESTER'S
19TH WARD

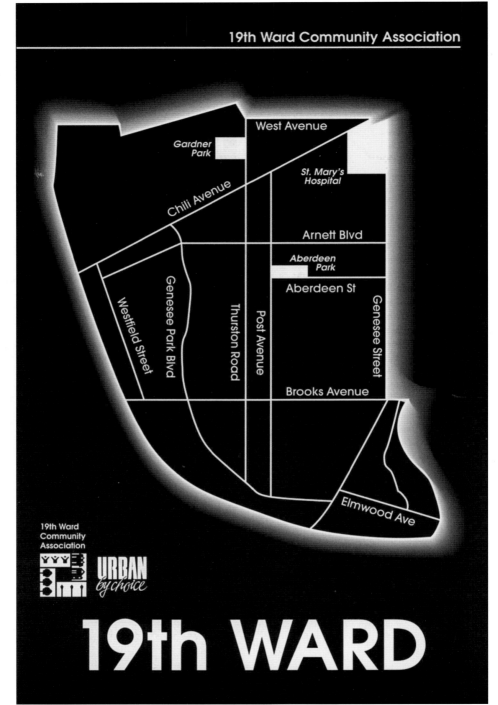

From a rustic settlement called Castle Town (sometimes written Castletown) near the present intersection of Brooks Avenue and Genesee Street, the 19th Ward has grown into a historic and elegant neighborhood. Its borders are defined here.

IMAGES
of America

ROCHESTER'S 19TH WARD

Michael Leavy and Glenn Leavy

ARCADIA
PUBLISHING

Published by Arcadia Publishing
Charleston SC, Chicago IL, Portsmouth NH, San Francisco CA

Printed in the United States of America

Library of Congress Catalog Card Number: 2005934390

For all general information contact Arcadia Publishing at:
Telephone 843-853-2070
Fax 843-853-0044
E-mail sales@arcadiapublishing.com
For customer service and orders:
Toll-Free 1-888-313-2665

Visit us on the Internet at www.arcadiapublishing.com

*This book is dedicated to the 19th Ward Community
Association on the occasion of its 40th anniversary.*

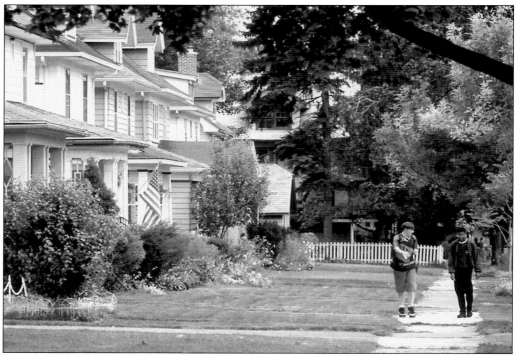

Young folk enjoy a shady residential street in the Sibley Tract. (Courtesy Rochester City Hall Photo Lab).

CONTENTS

ACKNOWLEDGMENTS

We are grateful to Rochester Photographic and Noeme Panke for the expert assistance provided. For their direction, enthusiasm, and encouragement, the authors acknowledge Cynthia Howk, Ira Srole, David Mohney, Ruth Rosenberg-Narparsteck, Barbara Sullivan, and David Hunt. The published resources include Robert F. McNamara's *St. Mary's Hospital and the Civil War*, Ruth Rosenberg-Narparsteck's *At the Rapids on the Genesee Settlement at Castletown*, and the Landmark Society of Western New York's 19th Ward Survey.

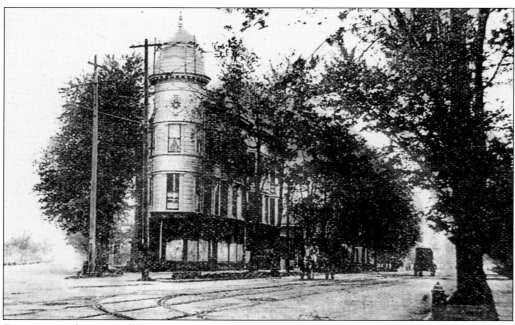

Streetcar tracks turn off West Main Street onto Genesee Street around 1890. The 19th Ward was one of Rochester's first "streetcar suburbs." Designed for a new and prosperous 20th-century American family eager to escape the congestion of the city, the area emphasized social institutions such as schools and churches. The flatiron building prominent in this image was long a landmark to 19th Warders. (Courtesy Rochester Public Library Local History Division.)

INTRODUCTION

As settlements go, Castle Town was nothing to brag about. Located along American Indian paths that would determine the present intersections of Genesee Street and Brooks and Plymouth Avenues, it was a trampled, muddy outpost of primitive homes and a portage for flat-bottomed boats. But it had the Castle Inn, run by Col. Isaac Castle. It boasted a long dance hall where "jolly good times were had there in those days by the young folk from the village of Rochester," according to George W. Fisher in a paper in 1935.

Castle Town was established just prior to 1800 by James Wadsworth of the Geneseo Wadsworths. The course of the Genesee River quickened here into harrowing rapids. Skilled boatmen were needed to transport passengers and freight across and sometimes down the turbulence. Every vessel from the south had to stop here. Wagons or sleighs would continue their journeys north to Rochesterville or west to Chili and Scottsville.

For a short time, Castle Town was a thriving trading center. More homes and boardinghouses were built. Increasingly, farms were being hacked out of the wilderness west of town. Diseases took many lives, however, requiring a cemetery on Congress Avenue. By 1822, the town had run it course. When Colonel Rochester secured the Erie Canal, he shifted dominance to the north, relegating Castle Town to an isolated boondocks more often referred to as "the Rapids." A feeder canal across the river would seal its fate. In 1838, the Genesee Valley Canal was excavated through old Castle Town. In June of that year, a clash with laborers became known as the Rapids Riot. Today a walkway follows the old canal bed, the towpath having later been used by the Genesee Valley Railroad.

In the 1890s, the expanding city began subdividing farms west of Bulls Head into building lots. Castle Town would become the 19th Ward, one of the largest continuous residential wards in western New York. With trolleys serving Genesee Street, Arnett Boulevard, and Thurston Road, a self-contained community with a small town flavor quickly developed. In the Sibley Tract, builders showcased impressive homes intended for the middle to upper middle class. These masterpieces featured stained-glass windows (some by Tiffany), chestnut and hardwood trims, Waterford chandeliers, Scalamandre wallpaper, curving staircases, and fireplaces flanked with leaded glass bookcases. Streets resplendent with turreted Victorians, neo-Gothics, Tudors, Colonial Revivals, and Georgians and blocks of the classic American Foursquares attracted doctors, lawyers, and skilled laborers. Many homes included cast-stone embellishments, Palladian windows, and inviting porches. Affordable and easily maintained, they were also stunning. Meanwhile, a highly value-based community lead to beautiful churches, colorful shops, quality schools, and a spectacular Frederick Law Olmsted–designed park.

Frank Capra could have filmed *It's a Wonderful Life* in the 19th Ward. His camera could have rolled down Thurston Road that night George Bailey ran through the snow shouting glad

tidings to storefronts and stunned neighbors. His proclamations to beloved savings and loans, theaters, and department stores could have been directed at Hunt's Hardware, Merrill's Variety Store, the West End Theater, and Louie's Sweet Shop. Cross Keys Tavern or Doubleday's could have been the bar where George's broodings pushed him toward emotional breakdown. And Clarence the angel could have used the Elmwood Avenue Bridge to convince George of his worth and to teach him to appreciate his very existence.

It was a new neighborhood catering to the American family of the prosperous 20th century. A harmless snobbishness flavored the ward. Some from Genesee Park Boulevard or the Sibley Tract were mildly disdainful of those from more modest streets and others were openly contemptuous of those north of Chili Avenue. Later soldiers would return from World War II with GI bills and a new outlook. The neighborhood would seem old-fashioned and fuddy-duddy. Low-interest loans would let them afford new suburban homes with larger yards and the latest home improvements, pitching the ward toward decline.

A real full-blooded cultural clash erupted in the early 1960s with school busing and the unethical real-estate practice of block busting. Race riots in the inner city in 1964 further diminished its reputation as a safe place to raise a family. White flight began as thousands of families found suburban living more appealing.

Residents of the 19th Ward, formerly accustomed to leaving doors unlocked and keys in cars, were now plagued with robberies. Businesses that had served the neighborhood for generations closed or relocated because of shoplifting and vandalism. Predatory gangs roamed Thurston Road and Genesee Street. Drugs, violence, and property neglect brought home values down. Sadly, many citizens felt they could no longer walk the once peaceful streets without feeling threatened.

In 1964, the determination of longtime residents resulted in the formation of the 19th Ward Community Association. Celebrating its 40th anniversary in 2005, it is one of the oldest such associations in the country. Its mission contains the goal "of neighbors striving to preserve the residential character of the neighborhood. The Association fosters and encourages mutual cooperation in the multi-cultural community." Efforts to establish a safe neighborhood for families are now paying off as property values continue to rise. The tide appears to have turned. Investment by the city and University of Rochester in the Genesee-Brooks area is filled with promise. Anyone raised in a city continues to feel a tug to the area, even after moving to the suburbs and small towns. This yearning is particularly strong in those who grew up in the 19th Ward. It is an unspoken desire to move back—to again call it home.

One

CASTLE TOWN
AND THE RAPIDS

A turbulent bend known as the Genesee River Rapids had significance long before LaSalle built a small post here or the Wadsworths of Geneseo established Castle Town. When wilderness ran uninterrupted to these banks, Paleo-Indians camped while following caribou herds. Senecas would later beat the trails that would become Scottsville Road, Brooks Avenue, and Genesee Street. The trail that became Plymouth Avenue brought Senecas to a fording place nearby, where they would cross the river and continue to their Finger Lakes villages. Slightly south, in Genesee Valley Park, was the western terminus of the Portage Trail, part of the more significant Ohio Trail, famous in this country's history. Today the Brooks Landing project is bringing exciting development here. The area's rebirth has circled back to where it all began.

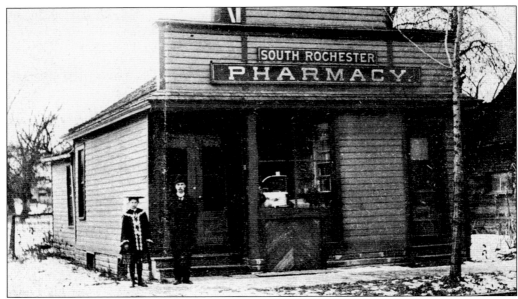

For a brief time, Castle Town was known as South Rochester. This old pharmacy, pictured in the early 20th century, stood on Brooks Avenue. Though a much-improved community by then, it still recalls the rugged settlement. Records of the 1845 Rapids Baptist Church (later Genesee Baptist) state that the community was peopled by those "neither urban or country but a people by themselves and of themselves peculiar and almost peculiarly bad." With limited schooling and religious opportunity, "the place became notorious for its bad morals," and the five hotels contributed to "putting their bottles to their neighbors' mouths to make them drunken . . . and five fiddles inviting them to nightly dances, which were marked by drinking and fighting and sometimes bloodshed." (Courtesy Rochester City Hall Photo Lab.)

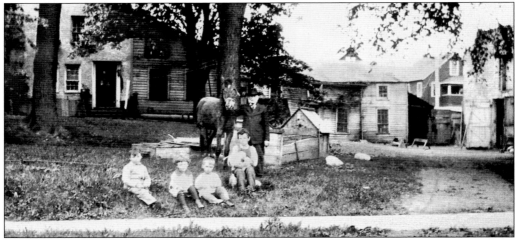

Shown about 1912, the former Brooks homestead holds remnants of old Castle Town. The gentleman with the horse is Mr. Carpenter, who acquired the Brooks home, which stood at the northwest corner of Brooks Avenue and Marsh Street. On the lawn, from left to right, are Jim Cook, James Paige, Teddy Eshelman, and Alton Cook. Note the contrast between the pioneer home at the end of the drive and the finer home to the left. This shows a progression of prosperity. (Courtesy Rochester City Hall Photo Lab.)

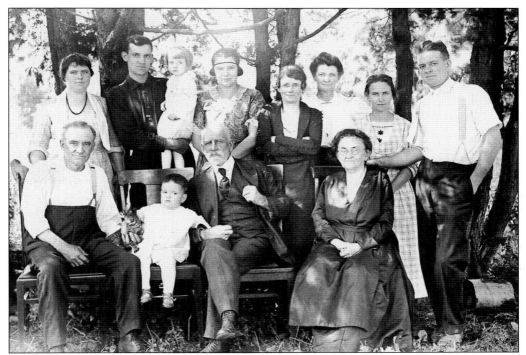

The Brooks and Paige families, connected by marriage, formed part of the community's social hierarchy. Calvin Brooks and his wife are seated in the center. On the left is Benjamin Paige, with his wife, Fannie Brooks Paige, behind him. Paige Street bears their name. (Courtesy Rochester City Hall Photo Lab.)

This tiny home on the south side of Brooks Avenue is a survivor from the old Castle Town–Rapids days. The rear section was added later. The house still has its wide plank floors and small box stairs leading to an upstairs bedroom. In the cellar are the original tree trunks that support the upper floors.

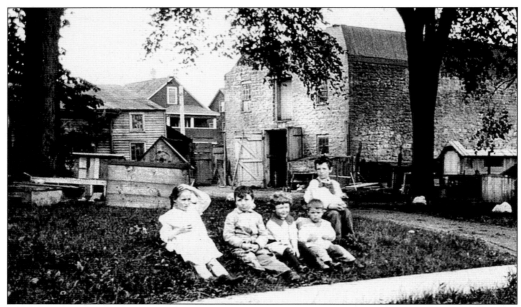

Neighborhood children pose on the lawn of the former Micah Brooks homestead in this westward view of Marsh Street. In 1810, the federal government commissioned three men to lay out a road from Arkport on the Susquehanna to Charlotte at the mouth of the Genesee. One was Micah Brooks, who stayed at an inn at the Rapids. He slept on a pile of straw covered with a bearskin. Brooks Avenue was named after the Genesee explorer, surveyor, and congressman. This is the present site of the True Saints Temple of the Apostolic Faith. (Courtesy Rochester City Hall Photo Lab.)

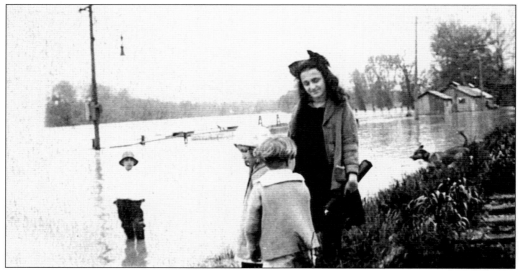

The Genesee River has flooded the Genesee-Brooks area in this image from the 1920s. The river flooded regularly, especially in Genesee Valley Park. The problem would not be solved until the building of the Mount Morris dam in the early 1950s. The children pictured are Bert Bricker (standing in water), Becky Freedman (center), and Mary and Ralph Bricker. (Courtesy Mary Bricker Wilson.)

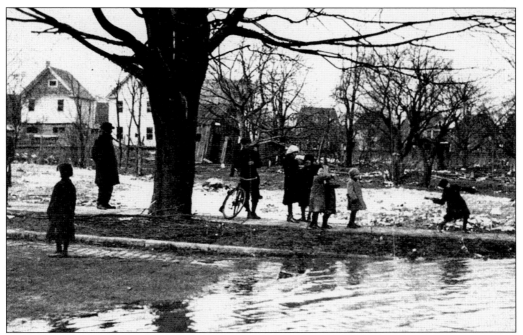

Kids stray to the edge of floodwaters along Brooks Avenue in 1914. Sometimes the water rose to the level of the tracks at the Brooks-Genesee crossing. (Courtesy Rochester City Hall Photo Lab.)

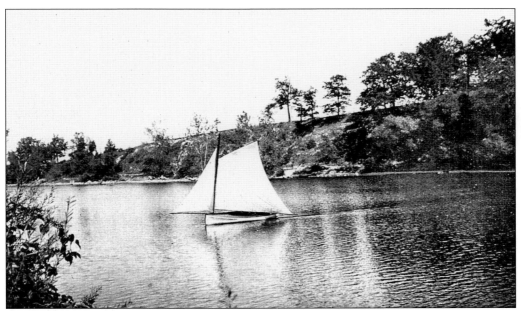

A sailboat cruises the Genesee River in this photograph showing the gentle slope of Oak Hill on the east bank. Excavations revealed that an Algonquin village occupied the site in 1200. In the 19th century, it was used as farmland and, beginning in 1901, as the Oak Hill Country Club golf course. A farmhouse was used as the original clubhouse. The University of Rochester acquired the property in the late 1920s and began development of its river campus in 1930.

13

This fabulous Queen Anne–style home at 72 Brooks Avenue was built by Howard Sneck, an attorney and owner of a Mumford farm. After Sneck was killed in an automobile accident at Bulls Head, his wife and daughter remained in the home. Daughter Mary Helen would reside here until the early 1990s. The homestead, built on a former apple orchard, had numerous outbuildings. The home is the only designated City of Rochester Landmark in the ward at this time. (Courtesy Rochester City Hall Photo Lab.)

This c. 1916 view, taken from the Sneck property and looking west across Marsh Street, shows the former Brooks homestead. (Courtesy Rochester City Hall Photo Lab.)

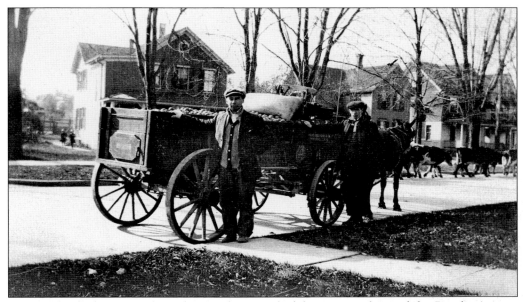

A wagonload of potatoes from the Snecks' Mumford farm sits in front of the Brooks Avenue home around 1914. The potatoes await delivery to city markets. The cows walking down the street have been unloaded from the railroad at Brooks and Genesee and are headed for a nearby farm. (Courtesy Rochester City Hall Photo Lab.)

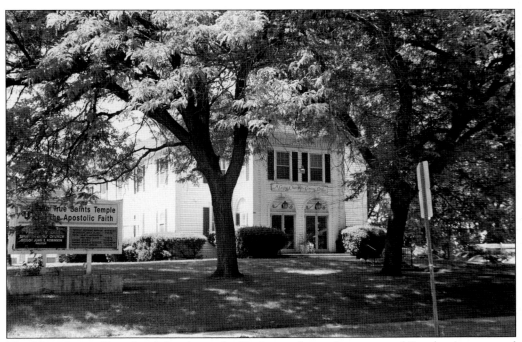

The True Saints Temple of the Apostolic Faith stands on the corner of Brooks Avenue and Marsh Street, the site of the former Brooks homestead.

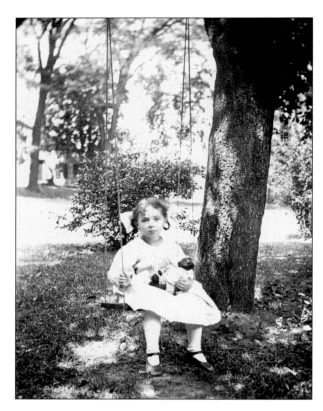

Mary Helen Sneck, an only child, would spend all but the last few weeks of her life in the Brooks Avenue house. Here she enjoys a tree swing with her favorite doll. (Courtesy Rochester City Hall Photo Lab.)

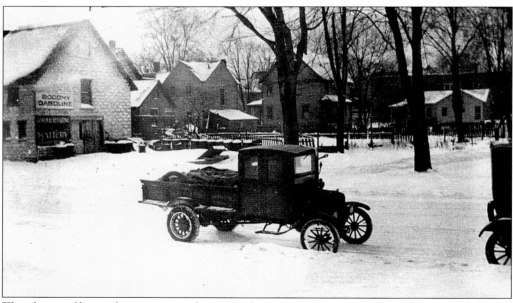

The clatter of horse-drawn wagons down Brooks Avenue was passing from the scene when this photograph of a truck—a new marvel—was taken in front of the Sneck home around 1917. (Courtesy Rochester City Hall Photo Lab.)

With the family china displayed behind her, Mary Helen Sneck welcomes guests to her home in the early 1990s. In the last few weeks of her life, Mary Helen was moved to the Episcopal Home. She died in 1995, and the entire Sneck household was later auctioned off. Seeing her precious heirlooms scattered was a sad affair for all who knew her. (Courtesy Cynthia Howk.)

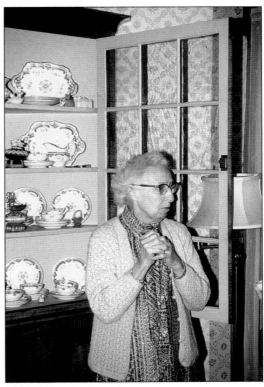

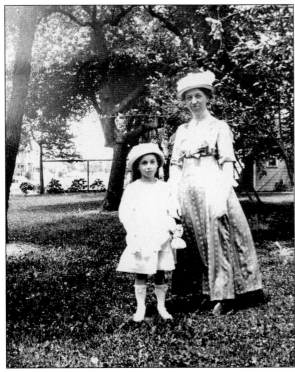

Mary Helen poses with her mother in the yard of their Brooks Avenue home.

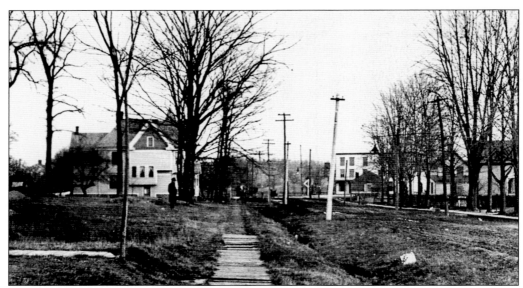

In this *c.* 1900 photograph of Brooks Avenue, some vintage elements of old Castle Town are recognizable. On the left is the Sneck residence. The large building ahead and to the right is a hotel that served travelers at the Rapids and those journeying on the Genesee Valley Canal and, later, the railroad. The small building in front of the hotel is Coulton's Blacksmith Shop. Note the wood sidewalks here.

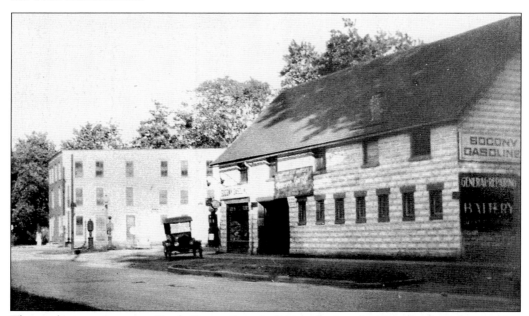

The modern era comes to Castle Town via a tin lizzie, whose unfamiliar clatter and sputtering threw frights into drowsy mares. In this *c.* 1913 image, a cast-stone commercial building houses a repair garage and Socony gasoline. The Genesee Rapids Hotel, at the far left, was the sight of regular brawls during the Rapids and Genesee Valley Canal days. The canal ran behind it. Longtime neighbor Mary Bricker Wilson recalls, "As children we were not allowed to go near the hotel because they sold liquor there."

18

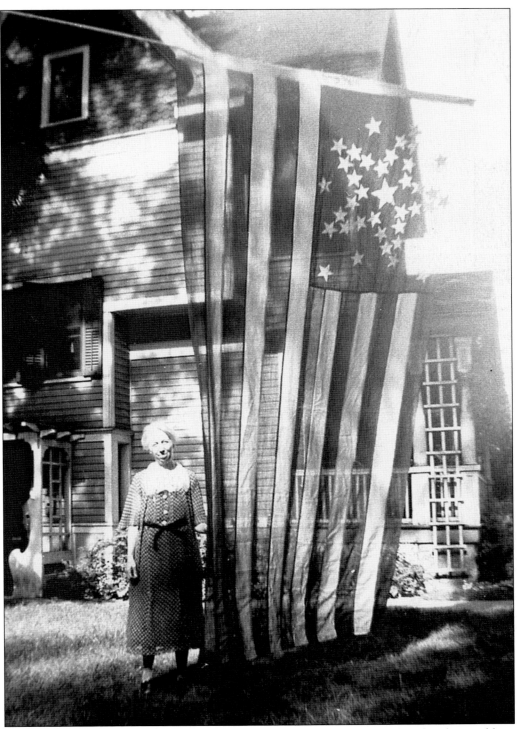

In 1919, Mary Helen Sneck's mother stands proudly in her side yard beside a flag designed by a family member. (Courtesy Rochester City Hall Photo Lab.)

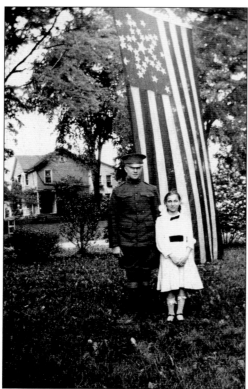

Mary Helen Sneck poses with her cousin Philip in 1919 during a celebration of his homecoming from France near the end of World War I. (Courtesy Rochester City Hall Photo Lab.)

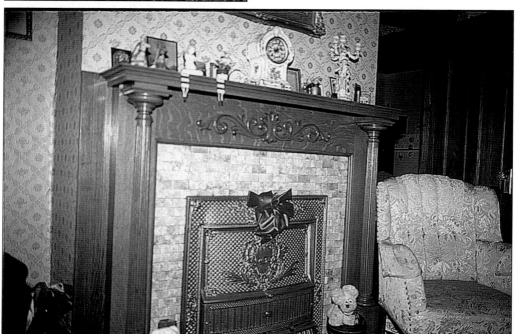

On cold Castle Town nights, friends visiting the Snecks could look forward to being warmed beside the parlor fireplace. (Courtesy Cynthia Howk.)

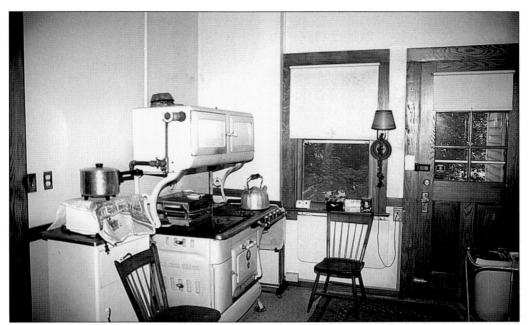

The interior of the Sneck home was virtually unspoiled when Cynthia Howk took this image in the 1990s. The original 1930s gas stove was still in use. The two chairs were part of a set Howard Sneck got from an Erie Canal boat, which had tight quarters requiring compact furnishings. (Courtesy Cynthia Howk.)

The Sneck summer home, pictured in the 1990s, was part of a collection of outbuildings and structures, most of which bore some degree of ornamentation. An architect had even prepared drawings for a chicken house. (Courtesy Cynthia Howk.)

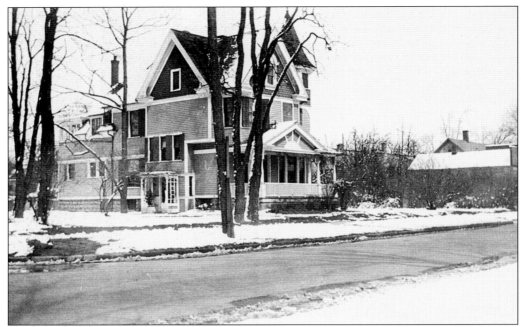

In this *c.* 1915 view, the porch stairs have been removed. Entry could now only be made from a door in the living room. Workers from the Snecks' Mumford farm, after coming to the house for their pay, would often visit nearby taverns and return to the house, where they would linger on the porch. Because of this, Mrs. Sneck did away with the stairs. (Courtesy Hunt's Hardware.)

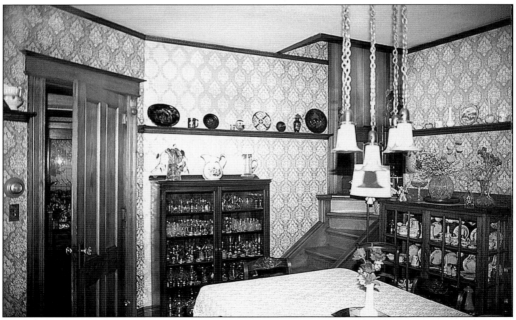

The dining room, with its angled walls, plate rail, custom-made ceiling lamp, and small stairway, still bears its original early-20th-century wallpaper. This rare view of a Castle Town interior was taken in the early 1990s by Cynthia Howk.

Around the corner, on Genesee Street, were important community leaders, the Hunts (not of the Hunt's Hardware family). Mary Helen Sneck poses with Mrs. Hunt, who is holding some lilacs, near the side porch of the house.

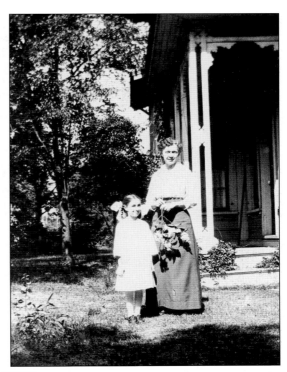

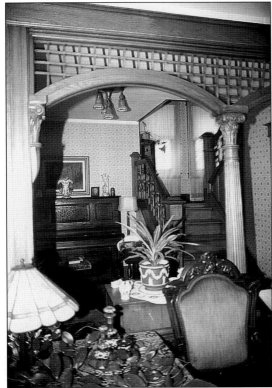

Mary Helen Sneck kept herself surrounded with her parents' original furnishings. The ivy on the table was propagated from a plant her mother started when Mary Helen was just a little girl. A view of the entry hall shows the high degree of craftsmanship that went into the lovely Queen Anne residence. The interior remained authentic and unspoiled when Cynthia Howk took this photograph in the early 1990s.

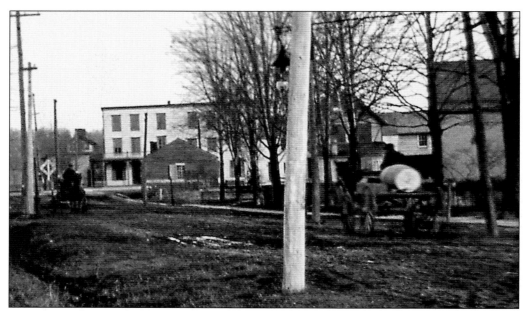

Demonstrated in the 1906 image above, Brooks Avenue in its Castle Town–Rapids days included a railroad crossing at the intersection with Genesee Street. The tracks were laid atop the old towpath of the Genesee Valley Canal. The hotel serving both transportation systems appears in the distance. Below, the avenue is shown in a 1940s view looking west from Post Avenue. Most vestiges of the old trading post settlement are gone. The dirt road that bore the traffic of heavy drays and stagecoaches is neatly paved. Farms and nurseries were subdivided starting around 1910, leading to a new and prosperous neighborhood.

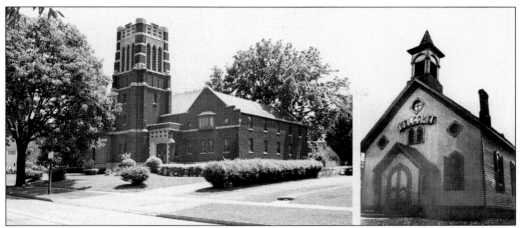

In 1925, the Genesee Baptist Church was completed on Brooks Avenue under the direction of prominent neighbor Philip Kron (Kron Street). The first church (right), originally located on Genesee Street, was moved here and incorporated into the new church, the wood exterior being bricked over in the process (note the two round windows). The congregation dates to 1827, when four families encouraged Otis Turner's daughters to teach Sunday school in their Brooks Avenue home. It quickly grew, and converts were baptized in the Genesee River. Today's congregation is richly diverse, comprised of both blacks and whites—a portion of those being from the Caribbean.

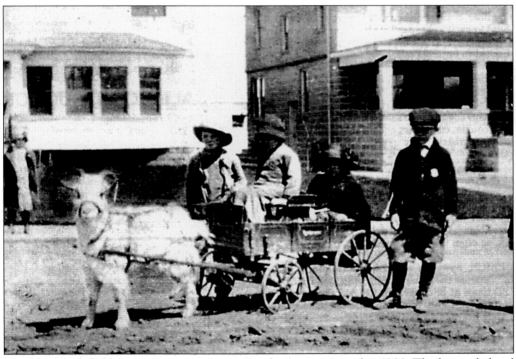

Neighborhood children enjoy a goat cart on Brooks Avenue just after 1900. The homes behind them, No. 500 (left) and No. 496, are brand new. The dirt road would be paved a few years later. At this time, the neighborhood was still rural. (Courtesy Hunt's Hardware.)

A farmhouse near the corner of Brooks Avenue and Genesee Park Boulevard served as the convent for Our Lady of Good Council. The church is to the left. The house was demolished and the school erected on this site in 1929. During rural times, nurseries were interspersed with west-side farms. The expansive Genesee Valley Nurseries of Frost and Company were bounded by Genesee Park Boulevard, Brooks Avenue, Genesee Street, and Thurston Road. (Courtesy Rochester Diocese.)

The residence at 595 Brooks Avenue later served as the convent for Our Lady of Good Council's Franciscan nuns who staffed the school. Pictured here in 1933, it was far more suitable than the original convent, the farmhouse in the previous image that was in "pretty sad shape," according to Rev. Edward T. Meager. (Courtesy Rochester Diocese.)

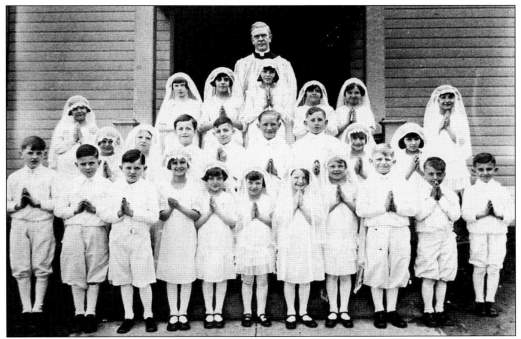

After receiving First Holy Communion at Our Lady of Good Council's parish, children pose outside the church at 650 Brooks Avenue around 1935. Rev. Edward T. Meager established the church in 1928. (Courtesy Rochester Diocese.)

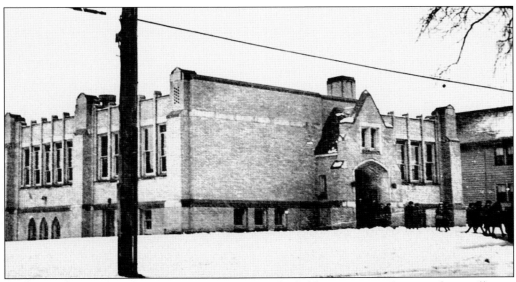

Reverend Meager then built a school for the parish children. "I grieved to see the small, wee children slogging through snow, rain and sleet to pursue a Catholic education at distant parochial schools. I longed to gather in the ones attending #16 and #37 schools," he lamented. The school opened at 79 Ernestine Street on September 28, 1930, during the Great Depression, when parishioners had little money for such an endeavor. The school is pictured here in 1933. (Courtesy Rochester Diocese.)

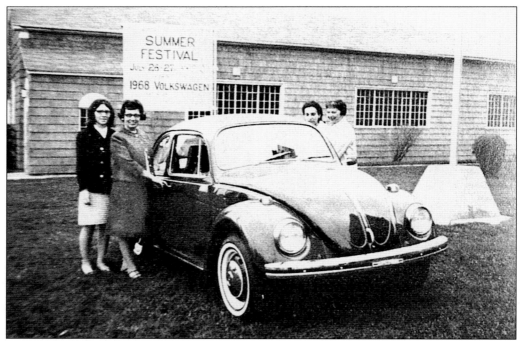

The 1968 Summer Festival on the campus of Our Lady of Good Council offered, in addition to games, musicals, and good food, a raffle to win this Volkswagen. (Courtesy Rochester Diocese.)

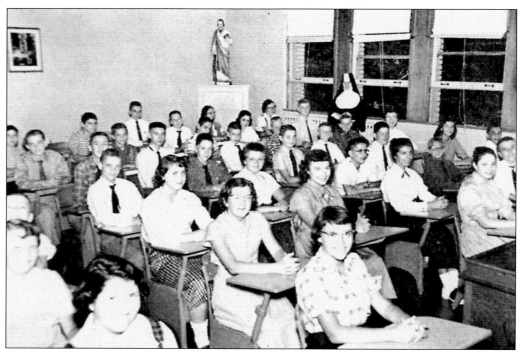

Our Lady of Good Council's eighth-grade students, under the direction of Sister John Marie, pose in 1957. (Courtesy Rochester Diocese.)

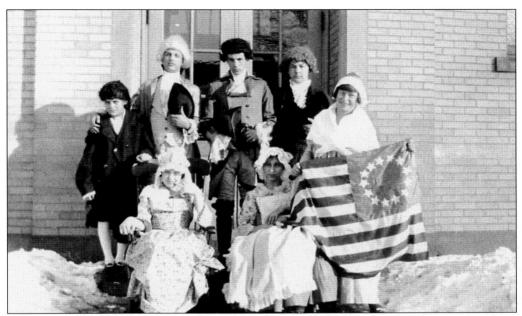

Students at Lewis Henry Morgan School No. 37 on Congress Avenue participate in a patriotic celebration. The school was founded in the Hunt home on Genesee Street, and this structure was built in 1917. Among the more identifiable patriots is George Washington, upper left in the white wig and unable to tell a lie. He has his arm around Paul Revere, while Betsy Ross shows off her flag. To the left of Ross is Mrs. Washington (Mary Helen Sneck). These are surprisingly sophisticated costumes. (Courtesy Rochester City Hall Photo Lab, Sneck Collection.)

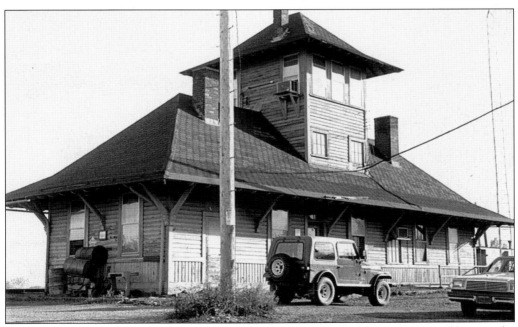

The former Baltimore and Ohio Brookdale yard station off Brooks Avenue, pictured here in the 1980s, is still in use, now providing service for the Rochester and Southern Railroad.

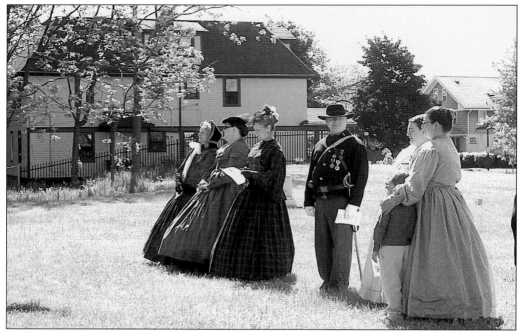

Every Memorial Day, members of the Sons of Union Veterans of the Civil War visit the Rapids Cemetery and conduct a ceremony consisting of dedications, music performances, readings, prayers, gun salutes, and placement of flags on veterans' graves. Pictured are the family members of Sons of Union Veterans Abraham Lincoln Camp No. 6.

The Rapids Cemetery, located on Congress Avenue, was established in 1810 by the Wadsworths, who set aside two acres for this purpose. This map shows alleys, trails, and avenues within the burial ground; the price of a lot ranged from 10¢ to 20¢ per square foot, depending upon which lane it was laid along. Some headstones were simply marked "Stranger." Mary Bricker Wilson recalls a path from Genesee Baptist Church to the cemetery: "The trail went past a tiny house in the woods. It was surrounded by roses. One day I was walking there and a man came out of the house. He gave me a rose."

Two

GENESEE STREET AND ARNETT BOULEVARD

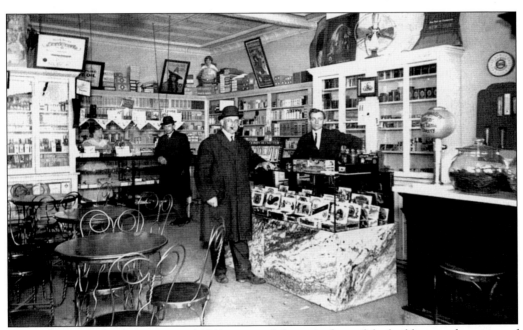

Carr's Pharmacy, shown here around 1911, occupied the main floor of the building on the corner of Brooks Avenue and Genesee Street. Before Carr's, it was the George J. Lewis and Company Pharmacy. Lewis's daughter Evelyn Lewis Meyers recalls that the soda fountain was very popular. Both stores offered a range of products in addition to prescriptions and over-the-counter drugs. These included cosmetics, greeting cards, cap guns, and other toys. Holiday items included Halloween costumes, Christmas decorations, and for the Fourth of July, Roman candles. Gentlemen could choose from a range of cigars displayed in Carr's noted marble cigar case. This building is now being incorporated into the Brooks Landing revitalization. (Courtesy 19th Ward Community Association.)

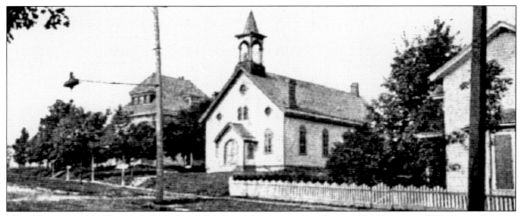

The First Regular Baptist Church of the Rapids appears in this *c.* 1905 image of Genesee Street. It was built in 1868 for the Rapids Mission on a parcel of land donated by Edward Frost. A muddy path beside the church led funeral corteges to the Rapids Cemetery. That path became Terrace Park. In 1899, the church became Genesee Baptist, and in 1922, the structure was moved to Brooks Avenue and incorporated into a new church being built there. (Courtesy Genesee Baptist Church.)

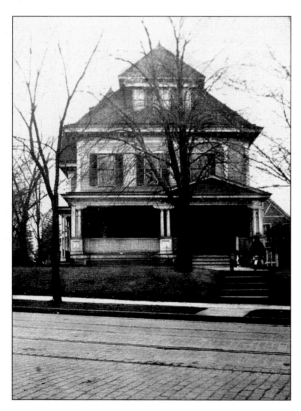

The impressive Hunt family home stands on Genesee Street amidst the newly laid streetcar tracks in the 1920s. School No. 37 was founded here. The roof of the house can also be seen to the left of the church in the previous image. (Courtesy Rochester City Hall Photo Lab.)

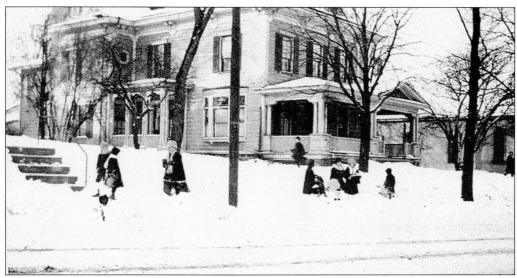

Students and some faculty take time for winter recreation in front of the Hunt residence on Genesee Street. (Courtesy Rochester City Hall Photo Lab, Sneck Collection.)

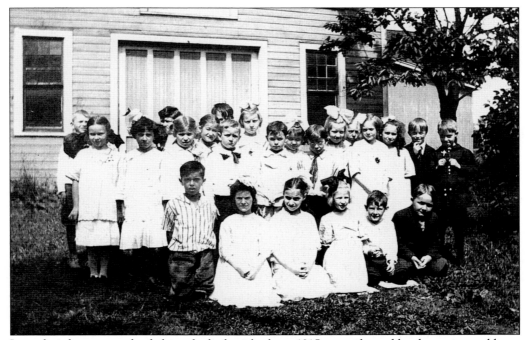

Large hair bows were the fashion for little girls about 1915, as evidenced by those pictured here. Students have taken time for a class portrait in front of the large carriage house on the grounds of the Genesee Street home. (Courtesy Rochester City Hall Photo Lab, Sneck Collection.)

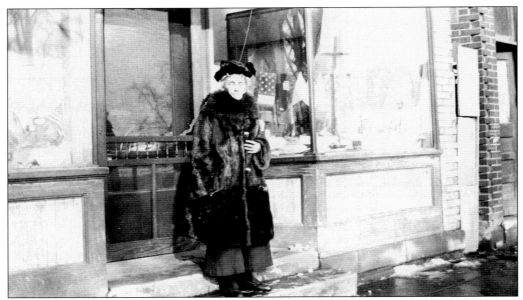

Matronly M. E. Wallace, called "Emmy" by neighborhood children, is snug in her mink coat outside the small store she ran on Genesee Street in Castle Town. Emmy lived in the back of the store. Children flocked here for penny candy, toys, and holiday decorations. Other neighborhood businesses near the intersection of Brooks Avenue and Genesee Street included Milligan's Dry Goods, Shalber's Hotel, Hinkle's Garage, Coulton's Blacksmith Shop, Carr's Pharmacy, and Bob Crawford's Barber Shop. (Courtesy Rochester City Hall Photo Lab.)

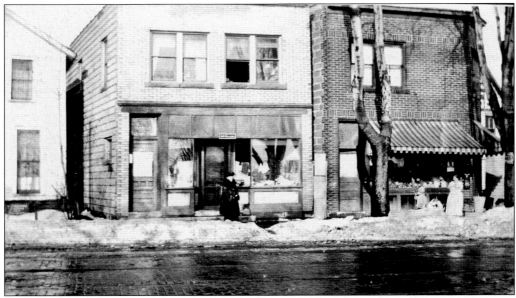

M. E. Wallace is pictured again in front of her neighborhood penny candy store. Mary Bricker Wilson recalls, "The store sold candy and toys. Girls got ribbons for their hair." To the right is a grocery store run by an Italian family. Mary remembers that "they had a goat." Genesee Street's stone paving and streetcar tracks glisten in a winter's thaw. (Courtesy Rochester City Hall Photo Lab.)

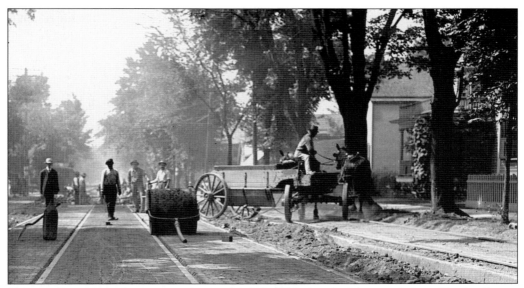

Genesee Street is under construction in this July 1914 view, looking south from Hawley Street. A heavy roller is used to compress the newly laid paving stones. The streetcar tracks will be operational as soon as the overhead wiring system is installed. Originally, portions of the road were temporarily paved with wood blocks. Their tendency to swell from moisture caused problems for trolleys, resulting in the use of special cars with higher motors. (Courtesy Rochester Municipal Archives.)

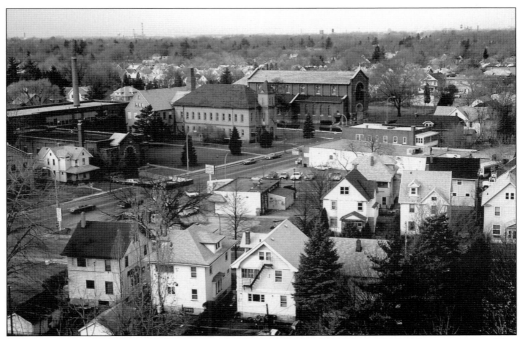

The campus of St. Monica's extends north along Genesee Street in this 1990s aerial view. The residential area is well shaded in the expanse of trees beyond this commercial district. (Courtesy Rochester City Hall Photo Lab.)

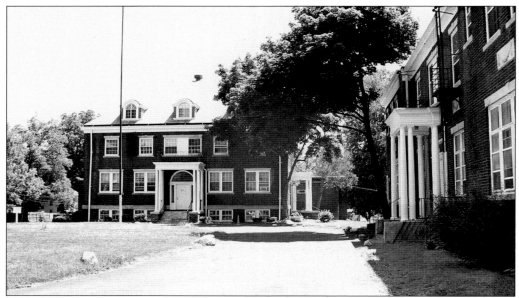

The city first left the matter of orphans to private and religious agencies. Eventually, there would be public institutions like the Western House of Refuge—a reform/prison for juveniles—and the Home for Truant Children. Religious agencies such as the Jewish Orphan Asylum, pictured here, provided a home to many neglected children. The three-building campus still stands on Genesee Street, now behind an apartment building.

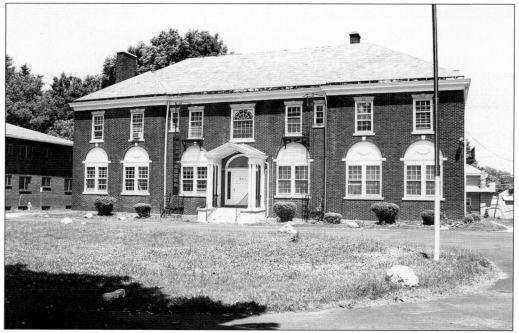

This is one of the three primary buildings of the former Jewish Orphan Asylum on Genesee Street. In these buildings, unfortunate children were cared for, schooled, and taught skills that would lead them toward self-sufficiency in later life.

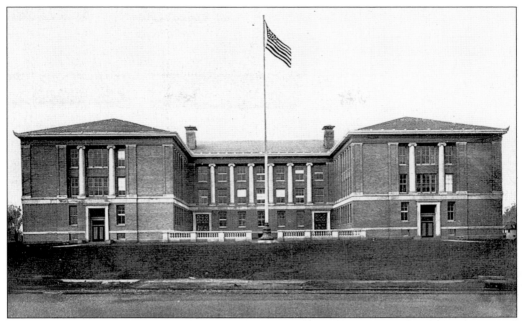

West High School opened on Genesee Street in 1905. Designed by J. Foster Warner, it represented the ward's commitment to education. It has since undergone several changes. Currently known as Joseph C. Wilson Magnet High School, it has received some of the highest ratings in the country.

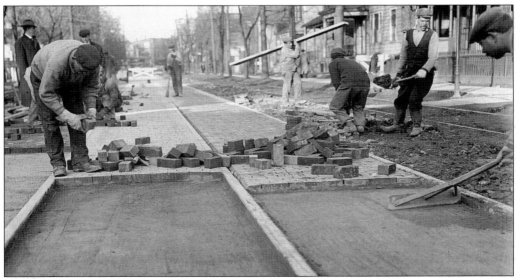

A work crew painstakingly sets stones in concrete during the paving of Genesee Street in 1914. (Courtesy Rochester Municipal Archives.)

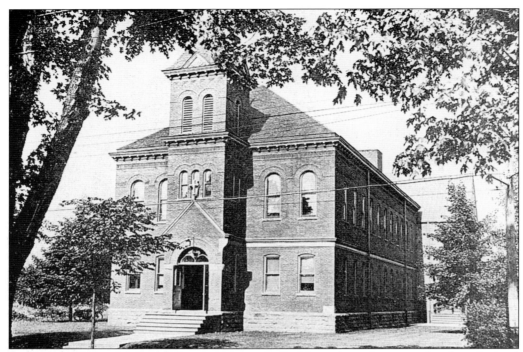

By decree of Bishop McQuaid, the cornerstone for St. Monica's combination church and school was laid in 1898 on a piece of property owned by St. Bernard's Seminary and set within farms and nurseries on Genesee Street. The parish was comprised of 65 families. St. Monica, a black woman born in Africa in AD 332, married a white Roman politician named Patricus. Her strong support of education and devotion to her faith made her a model for St. Augustine and led her to sainthood. (Courtesy Rochester Diocese.)

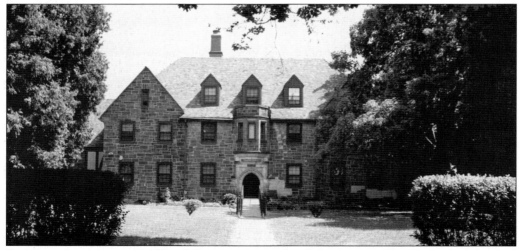

St. Monica's convent on Millbank Street was considered the finest in New York when finished in 1928. It was the third, replacing a house across from the school on Genesee Street purchased from the Reinhart estate. Prior to 1907, the sisters lived at the two orphanages at Bulls Head. This image dates from 1933. The former convent is now home to Sojourner House. (Courtesy Rochester Diocese.)

By 1914, St. Monica's had grown to 3,000 parishioners and required a larger church. Fr. Frederick Zwierlein headed up the project and, using European influences, concluded that the new church would be of "the fourteenth century basilica style and will seat 1000." Built as an Italian Romanesque structure, this church of "inspiring beauty" was dedicated in 1915. It is pictured here in 1933. (Courtesy Rochester Diocese.)

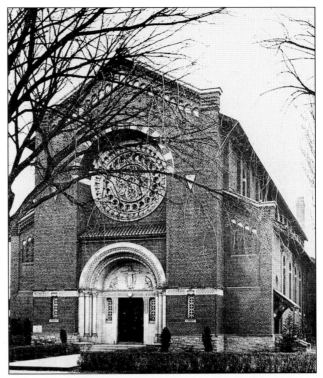

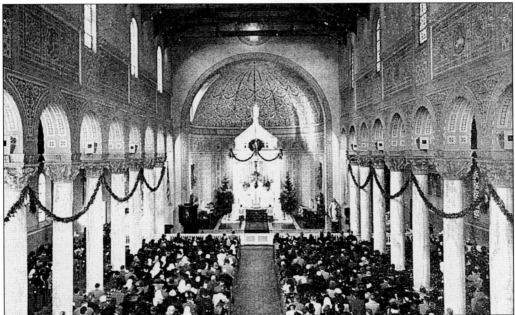

This 1940s interior view shows parishioners during Christmastime. Among the more noted features of the beautiful church are its marble columns. Costing $275, they were transported here by rail from Vermont and deposited at the railroad crossing at Genesee Street and Brooks Avenue. From there, they were brought to the construction site via wagon. (Courtesy Rochester Diocese.)

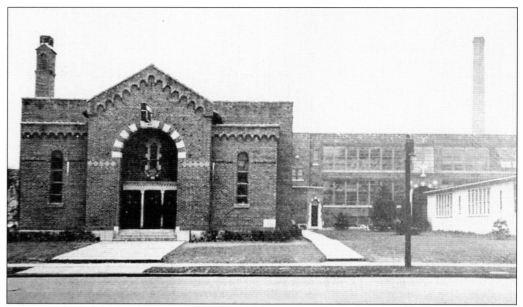

St. Monica's Hall opened in 1935 as a center for social and recreational activities. Built primarily as a school annex, the Italian Romanesque structure also housed an auditorium. By 1948, when this photograph was taken, 21 assistant pastors, 91 sisters of St. Joseph, and 25 lay teachers had already taught in and out of the campus. (Courtesy Rochester Diocese.)

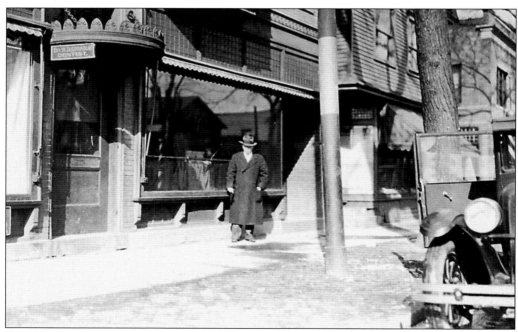

A gentleman stands outside a barbershop at 955 Genesee Street in the 1920s. Dentist W. D. Sprague operated his practice in the building as well. Genesee Street has always been a thriving thoroughfare with homes, apartments, schools, churches, nightclubs, shops, and firehouses. (Courtesy Rochester Municipal Archives.)

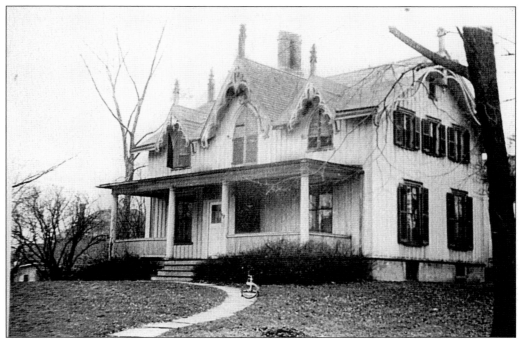

The history of 669 Genesee Street, this beautiful, rural Gothic-style residence from the Castle Town–Rapids days now gone, includes legends of the Underground Railroad. Built for Capt. Thomas Hyatt in the mid-1840s, it would be acquired by attorney George H. Humphrey in the 1850s. Humphrey, a fervent abolitionist, was open in his antislavery activities, leading to the legend that his house was a stop on the Railroad. Rumors spread of secret hiding places for runaway slaves and even a tunnel that exited at a distant location. Prior to demolition, a journalist inspected the property and found no traces of hidden places, trap doors, or tunnels, but admitted they may have been so well hidden as to avoid any detection. (Both views courtesy Landmark Society of Western New York.)

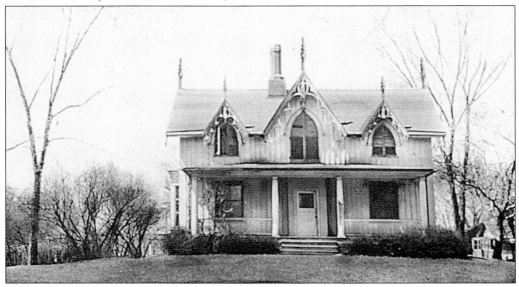

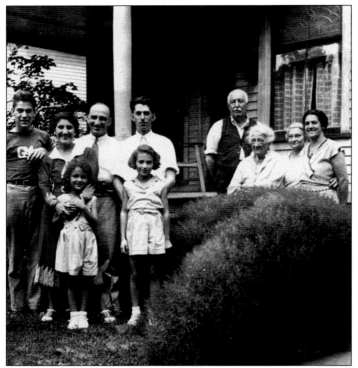

Members of the Wilson and Bricker families pose in front of their home on Genesee Street. Some are visiting from Canada. Longtime resident Mary Bricker Wilson, who provided this image, was born in this house. Her mother gave piano lessons here and small plays and theatricals were rehearsed here as well. The home is pictured below after the porch was enlarged. Workers involved in dredging the rapids in the 1920s sometimes rented rooms in homes along this stretch of Genesee Street.

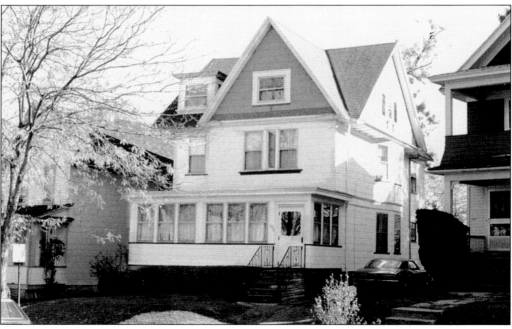

Few residences existed on Arnett Boulevard around 1900, but the streetcar tracks were indications of things to come. The ward was one of the first "streetcar suburbs" planned by the city. The promise of shady, tree-lined streets with sidewalks, quality schools, hospitals, and no heavy industry within the residential tracts was appealing to those wishing to escape the congestion and pollution of the city.

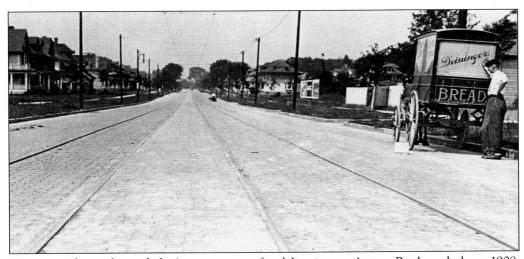

Deininger's horse-drawn baker's wagon stops for deliveries on Arnett Boulevard about 1908. There were a few building lots left—but not many—as the new neighborhood became increasingly popular.

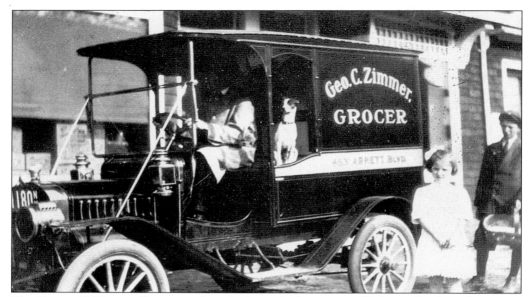

The George C. Zimmer Grocer truck, parked outside the store at 453 Arnett Boulevard, prepares for deliveries around 1914. (Courtesy Hunt's Hardware.)

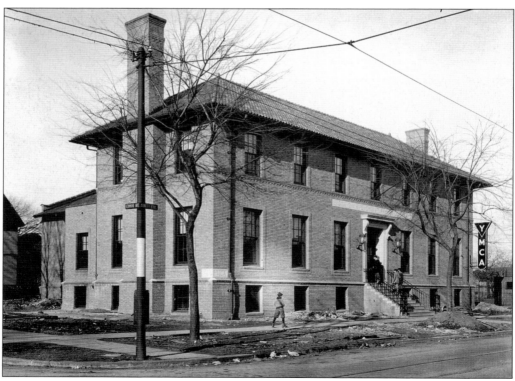

The southwest branch of the YMCA opened in 1923 at the corner of Arnett Boulevard and Kenwood Avenue. (Courtesy Rochester Public Library Local History Division.)

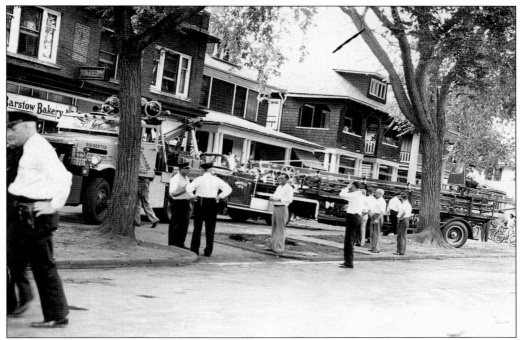

Fire truck No. 5 was on its way to a call in the 1950s when it collided with and demolished a brand-new Buick sedan on Genesee Street. No one was killed. The truck landed on the sidewalk near the Barstow Bakery. The fire department arranged for Browncroft Garage to use its World War II army surplus retriever "Big Bertha" to tow Truck No. 5 off the sidewalk and to the department's apparatus repair facility. (Courtesy Thomas Della Porta.)

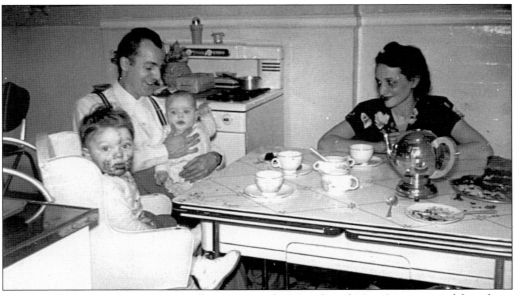

Post–World War II prosperity was well on its way when Frank and Mary Leavy visited friends on Genesee Street in 1949. Frank is holding his daughter Diane. The startled infant with chocolate over his face is unidentified.

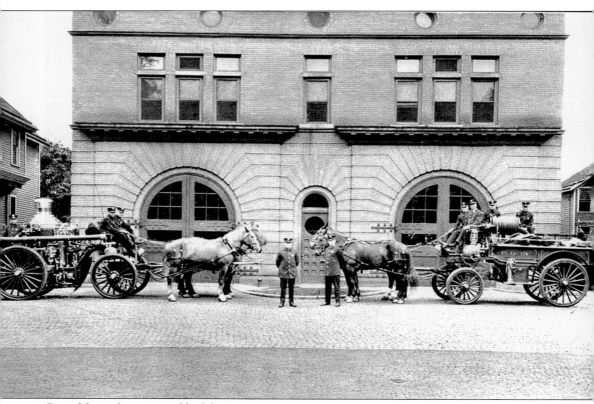

One of the earliest views of firefighting equipment on Genesee Street shows the firemen, horse-drawn steamer Engine No. 13 (left), and the hose wagon. This firehouse, standing opposite Clifton Street, was razed in the 1940s for the new St. Mary's Hospital. Another firehouse is located at the south end of Genesee Street beside St. Monica's. (Courtesy Thomas Della Porta.)

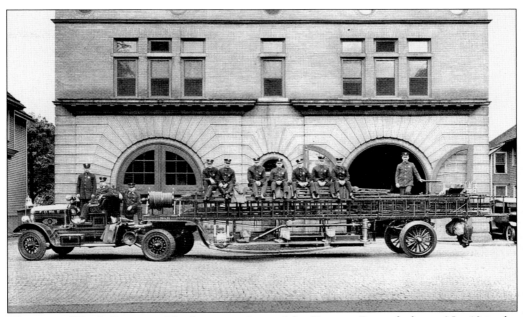

The crew of Truck Company No. 5 poses in front of the Genesee Street firehouse No. 13 in the 1920s. Shortly after World War II, medical interns training at St. Mary's Hospital were often assigned to the hospital's ambulance. During slow times, the firemen and interns would play card games together in the firehouse. (Courtesy Thomas Della Porta.)

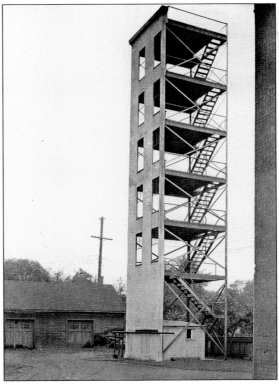

A Rochester Fire Department training ground was located behind the firehouse. A harrowing test for recruits required scaling an 85-foot-long wooden aerial ladder that was raised straight up. New fire recruits had to climb the ladder, go over the top, and then come down the other side. Anyone who could not accomplish this feat failed the test and was dropped from the recruit class. The more expanded training ground for the Fire and Police Academy was opened at 1190 Scottsville Road in the early 1950s. (Courtesy Thomas Della Porta.)

This view north down Genesee Street, where it intersects with West Main, shows the parking lot where Bulls Head Plaza would be built in the early 1950s. Beyond it is the famous flatiron building with its distinct dome. To the left is one of the first Wegman's grocery stores.

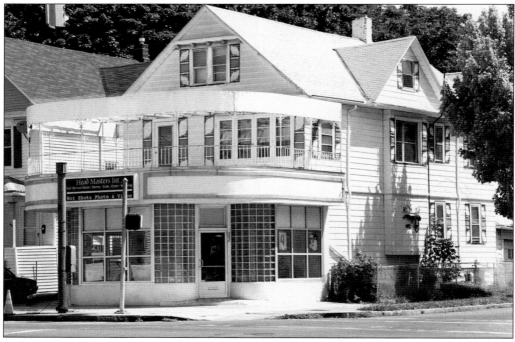

Valliere Drapery Studio had this beautiful storefront built on a residence at 394 Genesee Street in the 1950s. It was fabricated in steel, wrought iron, and glass brick and was particularly striking when lit up at night. Valliere was the place to go for custom drapery and high-quality fabrics.

Three

BULLS HEAD AND ST. MARY'S HOSPITAL

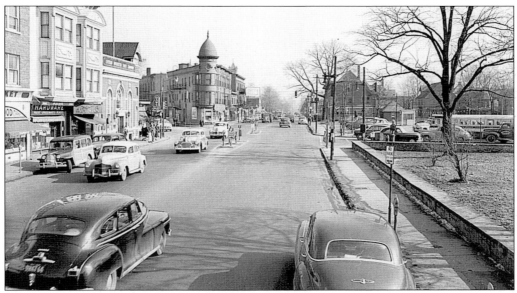

The area known as Bulls Head is deeply rooted in the city's history. Originally a cattle mart where stagecoaches proceeded west to Buffalo or Batavia, it became an intersection for Dutchtown and the 19th, 20th, and 11th Wards. It is named after the Bulls Head Tavern, built in 1827 by Derrick Sibley and Joseph Field, who supposedly named it after a pub in England. The anticipated cattle mart upon which the tavern owners hung their hopes filled the area with the stench of cows and sheep and little else. The failure of that enterprise led to the demise of the tavern, along with one slightly east at Willowbank called the Lamb's Tavern. To the right in this 1950s image is the original stone fence that surrounded the second St. Mary's Hospital, built during the Civil War. (Courtesy Rochester Municipal Archives.)

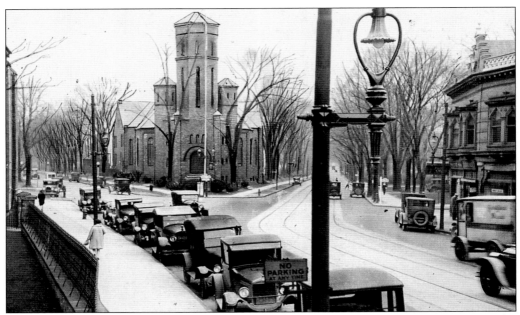

Streetcar tracks veer down West Avenue on the right in this 1928 Bulls Head image. The line terminated at a loop at Lincoln Park. To the left is Chili Avenue. This area was mostly wilderness with an occasional farm when tavern owners Derrick Sibley and Joseph Field offered travelers—over the lowing of penned-in cattle in the stockyard—tankards of rum and pickled lamb's tongue in the late 1820s.

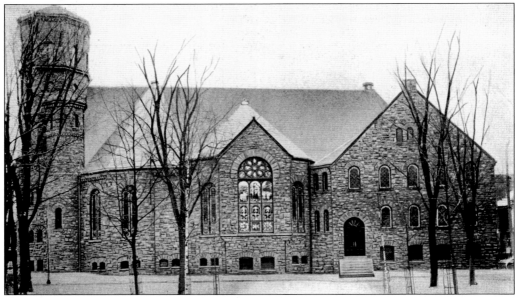

The style of the West Avenue Methodist Church is Richardsonian Romanesque, a trend inspired by noted Boston architect Henry Hobson Richardson, who was perhaps the most noted architect of the late 19th century. His ability to adapt Medieval Romanesque influences to contemporary needs and standards became such a sensation that he gave his name to this distinct design. City hall on Church Street is another example of his style.

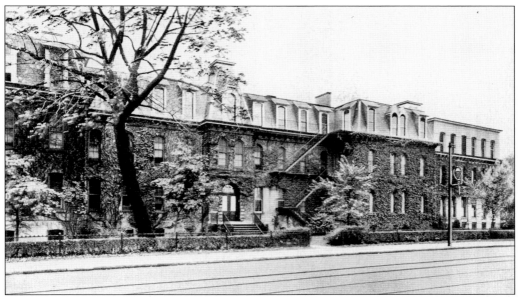

St. Mary's Boys Orphan Asylum originated in Halstead Hall, located on the corner of Buffalo (West Main) and Genesee Streets. The Sisters of Charity of St. Mary's Hospital used Halstead Hall as an overflow residence for wounded Civil War soldiers. In 1865, the Sisters of St. Joseph acquired the hall and four and a half acres, opening St. Mary's Boys Orphan Asylum the next year. A great need existed at the time because a large number of children had become orphaned and homeless after the war. The quarters were gradually enlarged, and St. Patrick's Girls Home opened on the grounds in 1895. It faced Clifton Street, the two asylums being back to back and separated by a fence. (Courtesy Sisters of St. Joseph.)

This early-1950s view of Bulls Head was taken from the new St. Mary's Hospital. The parking lot to the right is where the boys asylum stood. (Courtesy Rochester Municipal Archives.)

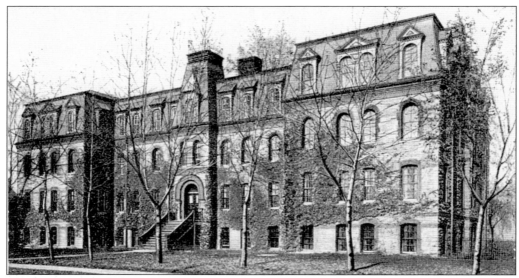

This 1908 postcard shows St. Patrick's Girls Asylum in the location where Bulls Head Plaza would later be built. Many children were orphaned when disease took their parents. Others were abandoned by single parents too destitute to care for them. Hopefully they were left at some private or religious benevolent institution where they would be cared for. Too often, though, the children were left to roam the streets, harassing people downtown. The city finally had to do something about these "urchins," and several truant homes were established.

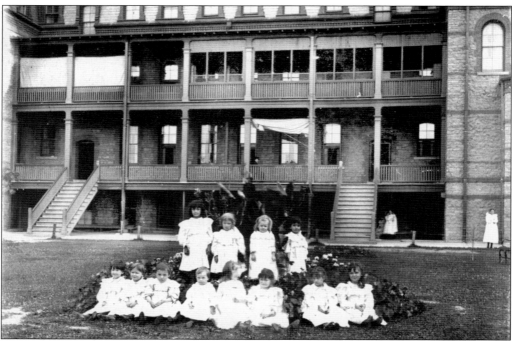

Orphaned girls pose on the grounds of St. Patrick's Girls Asylum. It was built in 1895 on the four-and-a-half-acre parcel that included St. Mary's Boys Asylum. This facility faced Clifton Street and was administered by the Sisters of St. Joseph. (Courtesy Sisters of St. Joseph.)

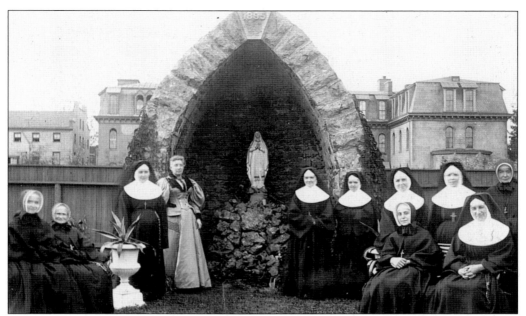

Sisters and a laywoman pose beside the shrine to Our Lady of Lourdes on the grounds of the girls asylum about 1896. Some of the sisters are wearing the traditional habit, while others are donning a bonnet rather than a headdress and veil. These were "lay sisters," members of the congregation who did domestic work. Behind them is the back of St. Mary's Boys Asylum. (Courtesy Sisters of St. Joseph.)

This detail, taken from the top image, shows the original Bulls Head Tavern on the left. It was described in 1932 by Walter H. Cassebeer as being a three-story stone building with a center entrance. There was a fanlight above the entrance door and cornices along the front and rear façades. The end walls had two chimneys and two attic windows. The structure later became Halstead Hall, a water cure and sanitarium, and then an annex to St. Mary's during the Civil War. St. Mary's Boys Asylum was also started here. The structure was razed in 1908.

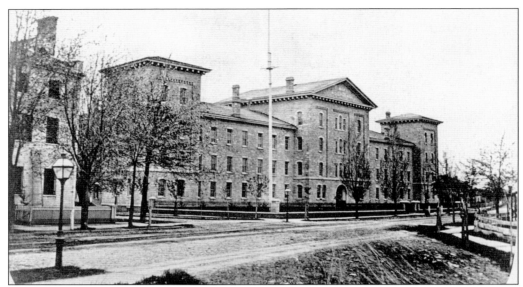

St. Mary's Hospital, pictured in 1865, was organized in 1857 by the Sisters of Charity from Buffalo. Under the guidance of founder Sister Hieronymo O'Brien, the sisters set up shop in two horse stalls on property purchased from Derrick Sibley. At the outbreak of the Civil War, both the Union and Confederate authorities looked to Catholic sisterhoods to nurse the wounded. The hospital was designed in the Lombard Romanesque style by A. J. Warner and built in 1863. Soldiers were moved in as fast as sections were completed. The flagstaff in the center of the photograph was a liberty pole, built by convalescing soldiers and dedicated on Independence Day 1865.

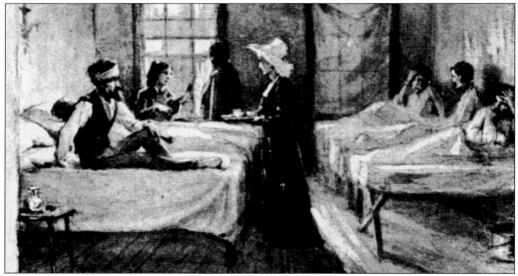

When Civil War invalids started arriving from the Erie depot, they were, according to Sister O'Brien, "pitiful" and "disgusting," with festering wounds, malnutrition, sunstroke, venereal diseases, and fevers. Worst were the "walking dead" released from Georgia's notorious Andersonville Prison, who were skeletal, most weighing no more than 60 pounds. The sisters managed to nurse many back to vigor. City Hospital, east of St. Mary's, was built during the war to help with the wounded as well. (Courtesy Unity Health/St. Mary's Hospital Archives.)

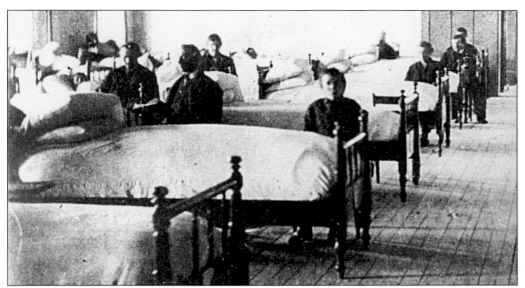

This rare *c.* 1865 stereo view shows the soldiers' ward. A federal contract paid $5.50 a week for every soldier patient, considering this a military hospital. Union soldiers from other states were treated as well. Sister Hieronymo stated, "The suffering of these poor soldiers during the late war can never be told." Of their injuries, she remarked, "Their wounds would be in terrible condition, and it was pitiful to see them." The sisters tended their ailments, wrote their letters home, and read to them. The community helped by organizing bazaars and other fund-raisers. (Courtesy Unity Health/St. Mary's Hospital Archives.)

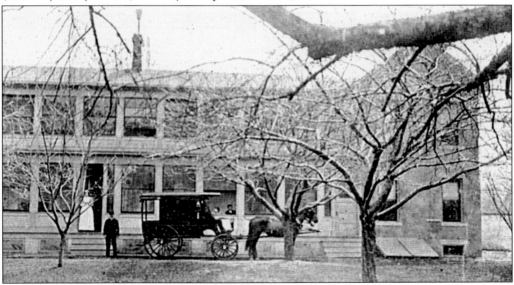

The Annex for Contagious Diseases, pictured about 1914, was built during the Civil War and used during outbreaks of cholera, smallpox, and typhoid. When all the buildings on the grounds were filled during the war, soldiers were put in tents. When two soldiers turned up with smallpox, Sister Hieronymo personally wrapped each of them from head to toe in heavy blankets and put them in isolation. The annex was demolished and a nurse's home built on the site in 1923. (Courtesy Unity Health/St. Mary's Hospital Archives.)

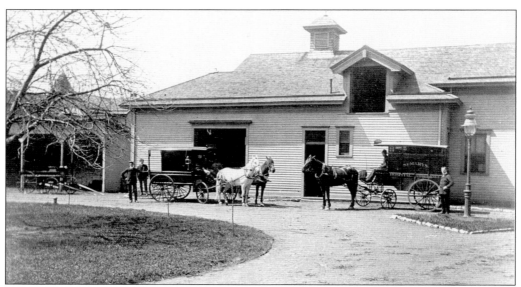

An ambulance barn provided storage for the vehicles and stalls for the horses. The new barn, shown around 1896 when ambulance service began, was razed in 1956. (Courtesy Unity Health/St. Mary's Hospital Archives.)

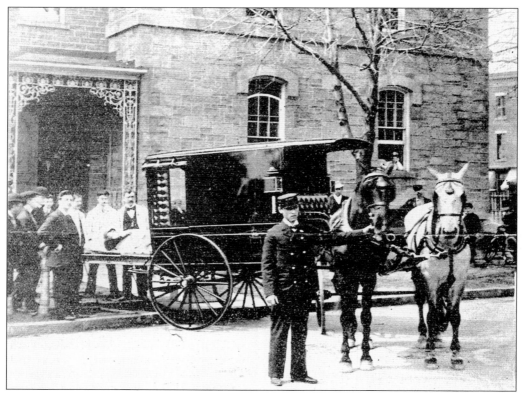

The hospital's new ambulance is displayed during inauguration of service in 1896. (Courtesy Unity Health/St. Mary's Hospital Archives.)

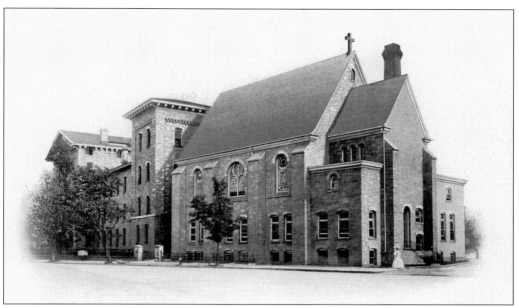

The chapel for the hospital was constructed on the corner of West Avenue and Ardmore Street in 1906. It was razed in 1959. (Courtesy Unity Health/St. Mary's Hospital Archives.)

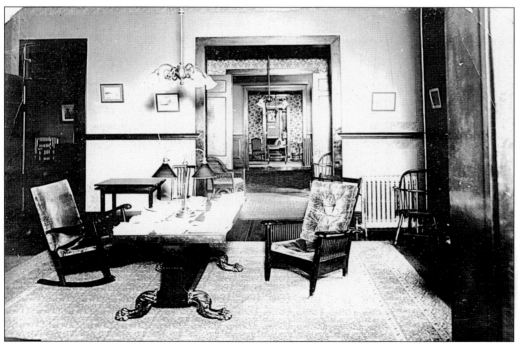

This rare interior view of the old hospital shows waiting rooms and administration offices. Old gasoline lamps have been replaced with electric lights in this image from about 1916. Mary Leavy, who worked at the hospital during the Depression, recalls how clean it was kept: "The floors were wood planks. No mops were used. Workers were down on their hands and knees with wash pails and brushes, scrubbing and scrubbing!" (Courtesy Unity Health/St. Mary's Hospital Archives.)

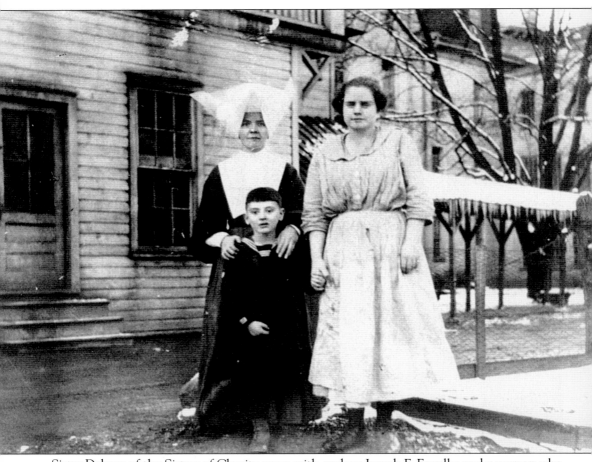

Sister Delores of the Sisters of Charity poses with orphan Joseph F. Engelke and a woman who worked in the kitchen about 1916. Joseph was an abandoned baby adopted by the Sisters of Charity, even though the Sisters of St. Joseph operated orphanages across the street. (Courtesy Unity Health/St. Mary's Hospital Archives.)

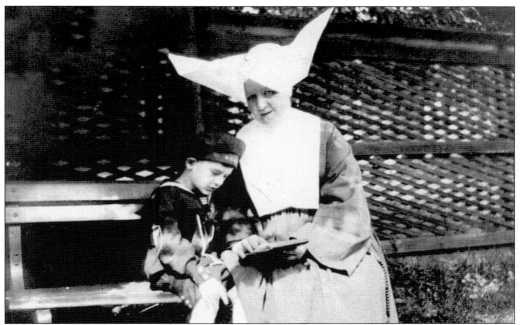

On the back of this photograph, Joseph Engelke wrote, "Sr. Emily Nichols reading to me in the back of the hospital. One of my prize pictures. Sr. Emily died about 1935 or 1936." The photograph was taken around 1914. (Courtesy Unity Health/St. Mary's Hospital Archives.)

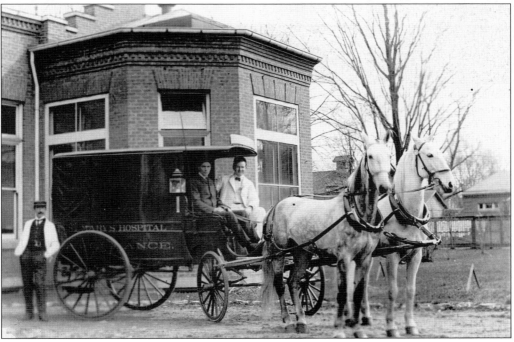

An ambulance crew with a matched team appears on the hospital campus in 1905. The horses were faithful, much like fire horses—and just as fast. (Courtesy Unity Health/St. Mary's Hospital Archives.)

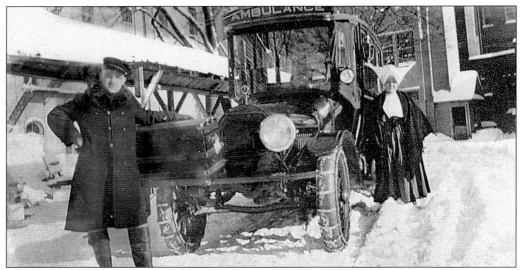

An ambulance driver readies his vehicle for service. Chains have been attached to the tires of this Cunningham-built ambulance for better traction in deep snow and on ice. A nun looks on determinedly in this 1914 image. (Courtesy Unity Health/St. Mary's Hospital Archives.)

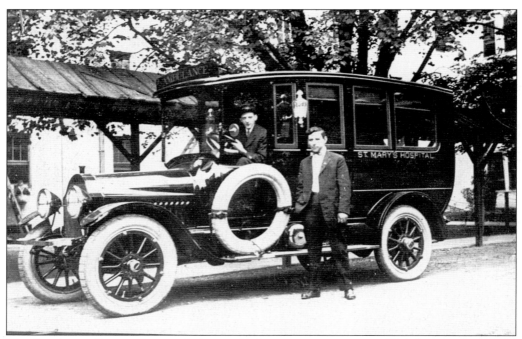

This handsome Cunningham ambulance, the first put into service, in 1914, features decorative side lamps. To the right of the spare tire, along the running board, is a mechanically operated brass alarm bell. All Cunningham vehicles manufactured at the Canal Street factory were hand-built masterpieces. (Courtesy Unity Health/St. Mary's Hospital Archives.)

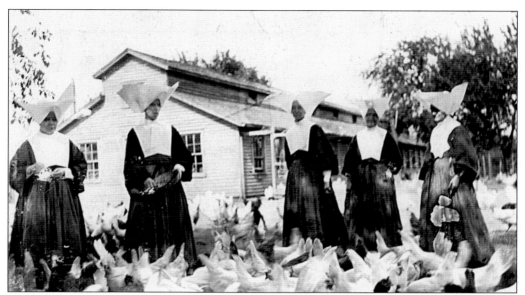

The sisters worked a farm about four miles down Chili Avenue. St. Mary's Farm operated from the Civil War era to 1940, raising crops, chickens, and other livestock to provide food for the hospital. Here it is feeding time for the chickens about 1914. (Courtesy Unity Health/St. Mary's Hospital Archives.)

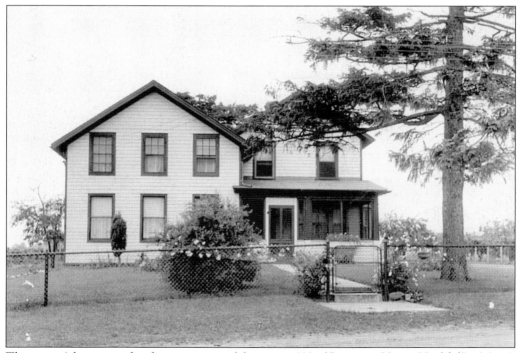

The sisters' house at the farm is pictured here in 1932. (Courtesy Unity Health/St. Mary's Hospital Archives.)

Joseph Engelke poses with one of the nuns. (Courtesy Unity Health/St. Mary's Hospital Archives.)

Infant Vincent Vardnzanta, possibly an adopted orphan, enjoys the attention of Sisters Clementine (left) and Delores (right)—wearing their distinct headdress—at the farm in 1914. (Courtesy Unity Health/St. Mary's Hospital Archives.)

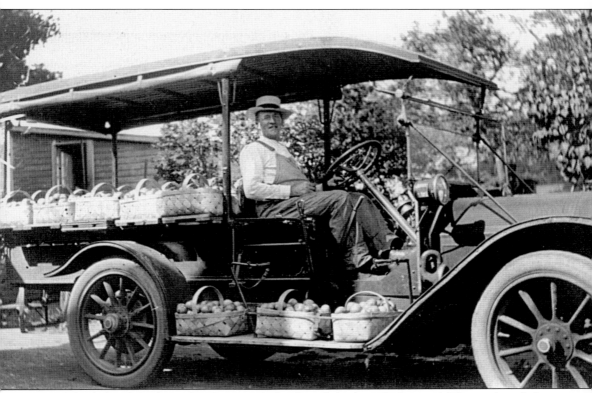

A truck loaded with baskets of apples is ready for the ride back to the hospital. The unidentified driver was also the farm manager. (Courtesy Unity Health/St. Mary's Hospital Archives.)

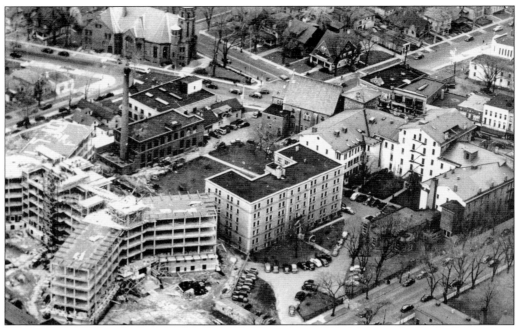

This aerial view shows the new St. Mary's under construction in the early 1940s. It has been suggested that the unusual design was inspired by the distinct headdress worn by the Sisters of Charity. The old hospital, to the right, would be demolished for a parking garage. (Courtesy Unity Health/St. Mary's Hospital Archives.)

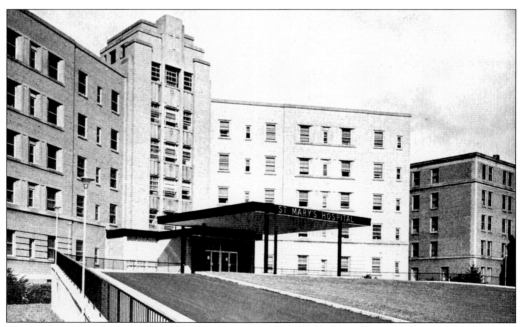

This entrance and approach to St. Mary's, pictured in 1961, faces Genesee Street. The hospital closed in the 1990s, and the facilities are now operated by Unity Health. (Courtesy Unity Health/St. Mary's Hospital Archives.)

Four

THE WARD'S GRAND AVENUES

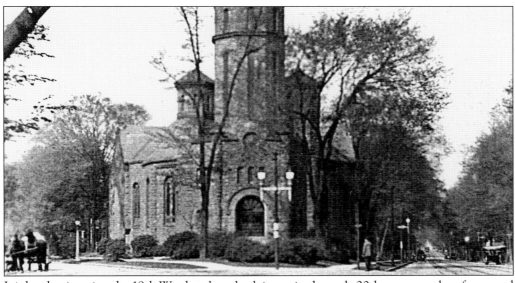

It is hard to imagine the 19th Ward as the suburb it was in the early 20th century, when farms and nurseries were subdivided into building lots. In many ways, it was a self-contained community with the characteristics of a small town. The desire to welcome visitors in grand style was not overlooked in the ward. Two "Grand Avenues"—West and Chili—made lasting impressions on those entering the southwest neighborhood. They did much to attract prominent east-siders to the new neighborhood and form a social hierarchy. These were prestigious addresses where doctors, lawyers, professors, and other professionals showcased their wealth with magnificent homes. Architects such as J. Foster Warner, Claude Bragdon, Dryer, and James Burns Arnold left masterworks that endure today. The craftsmanship and quality of materials rivaled anything used on East Avenue. The West Avenue Methodist Church stands fortresslike, singularly welcoming visitors to Chili Avenue (left) and West Avenue (right).

J. Foster Warner designed this neoclassical Revival at 100 Chili Avenue. Built in 1910 for Thomas A. Whittle, it stands at an angle to the street on a large lot with a winding drive. The 30 sheets of plans, dated 1904, include elevations, a croquet court, a tennis court, roses, a pergola, a clothes yard, and some smaller structures. The large two-story residence is one of the most formal on the avenue, featuring Ionic pilasters, columns, a Japanese-influenced balustrade, and neoclassical detailing. The drawings include a landscaping scheme and a list of plantings for the formal garden. The sister house for this stunning structure is located on Barrington Street.

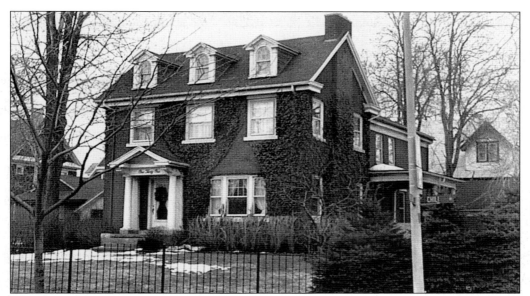

The original portion of 131 Chili Avenue, the rear ell, is one of the oldest structures in the ward, dating to 1847. The farm upon which the house was originally situated extended from Genesee Street (prior to St. Mary's Hospital) to Frost Avenue. Johnson and Anne Southwick then acquired the property, Johnson being a carriage maker for the James Cunningham and Son Carriage Company. The front addition was added around 1918. The home is one of the few Federal Revival–style residences in the ward. (Courtesy Landmark Society of Western New York.)

President of the Vacuum Oil Company, Hiram B. Everest had this 8,000-square-foot mansion built on lot 15 of the Martindale Park Tract around 1905. The graceful roof, with its exaggerated eaves, has a touch of the Orient. Situated on a large lot at 96 Chili Avenue, the building is stately and even austere. A modified American Foursquare, it is embellished with rich details such as fluted Doric columns, brackets under wide eaves, and pilasters. (Courtesy Landmark Society of Western New York.)

This graceful 1906 brick Georgian-style residence stands at 203 Chili Avenue. Bill and Barbara Sullivan purchased the home in 1981 and began a two-decade restoration using bits of information provided by descendants of the first owners, John and Eme Fulreader. John was secretary-treasurer of the James Cunningham and Son Carriage Company, manufacturer of elegant carriages and then luxurious automobiles. Eme loved gardening and refused to have a garage built, preferring the extra land. Her husband, employed by one of the premier automobile manufacturers in the country, had to park his car in a neighbor's garage. (Courtesy Bill and Barbara Sullivan.)

This 1930s photograph of Chili Avenue was taken from the Fulreaders' bedroom. Avenues such as this often disappeared overnight, but the 19th Ward Community Association, established in 1965, lovingly tended its grand old dame, protecting her from the ravages of decline and neglect. In 2004, the street underwent a major rejuvenation that included its narrowing and the installation of attractive streetlamps. (Courtesy Rochester City Hall Photo Lab.)

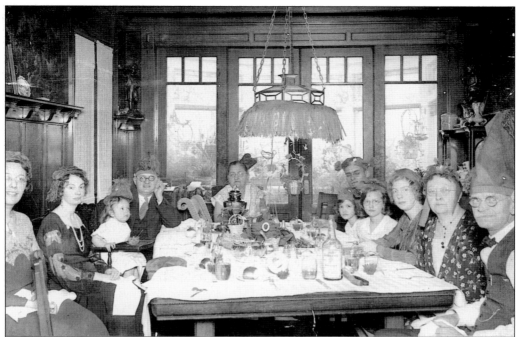

The Fulreader clan poses around the dining room table during a New Year's Eve party in the 1930s (note the festive hats). The exquisite craftsmanship includes a richly carved fireplace and light fixtures designed specifically for the house. Each room is trimmed in a different wood. The quarter-sawn oak floors have inlaid parquet borders, and the Arts and Crafts–style library features stenciled burlap on the walls. In the distance is a solarium where Eme started her tomato plants in the winter. (Courtesy Bill and Barbara Sullivan.)

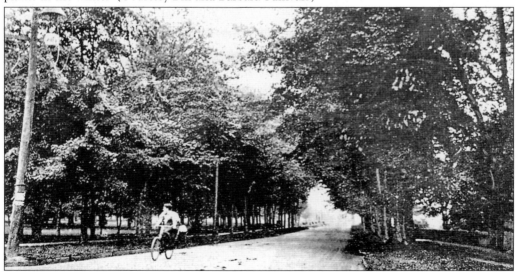

This 1906 image shows what Chili Avenue looked like when the Fulreaders built their home. There were farms, nurseries, and taverns to greet travelers. Plans were well along, however, for making this a street of fashionable homes intended for the ward's social hierarchy. (Courtesy Rochester Public Library Local History Division.)

Mathew Elliot was a manager at the Erie Foundry Company in 1910, when his family moved into this Tudor-style residence at 249 Chili Avenue—previously assigned as lot 65 of the Hillcrest Tract. Its distinctive façade of random cut stone presents an imposing, almost fortresslike edifice to the avenue. A secondary façade faces Rugby Avenue. Heavy half-timbered brackets and stone coping set into pebbly stucco make this one of the more ambitious homes in the area. (Courtesy Landmark Society of Western New York.)

A number of homes were of this style—large with a center entrance and a porch across the entire front. The trim here was highlighted in several colors during the "painted lady" trend of the 1970s and 1980s. Owning many of these homes, doctors held their offices in finished basements often with wood floors. More formal side entrances were built to welcome patients. Some basements had billiard and game rooms.

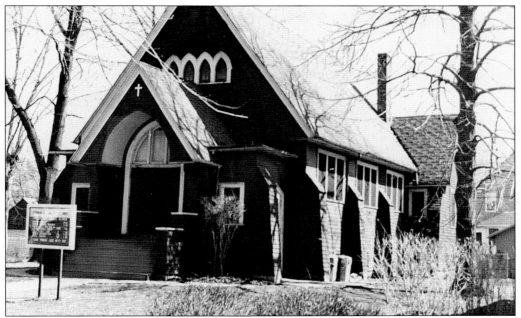

As farms west of Bulls Head were subdivided into building lots, Episcopalians moving into the district held services in the schoolhouse of Gate's School No. 3, on the corner of Chili Avenue and Gardiner Park. In 1897, they built the above mission chapel at 136 Fillmore Street. The cruciform plan contains Gothic touches such as in the front double-door and windows. Note the buttresses flanking the stained-glassed windows. The interior had reversible pews that allowed the congregation to face the back of the church rather than the altar during entertainments. This site is now home to the Church of the Firstborn. Seen below, St. Stephen's Episcopal Church was built on Chili Avenue in 1912. Neighbors recall attending the long-standing Strawberry Festival there. (Above, courtesy Landmark Society of Western New York.)

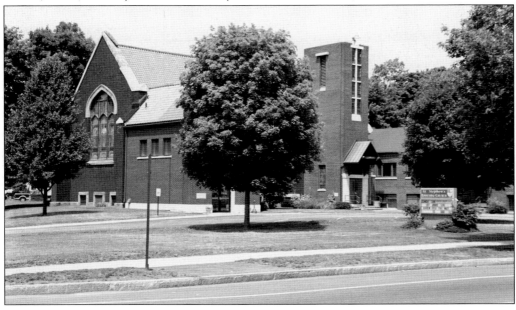

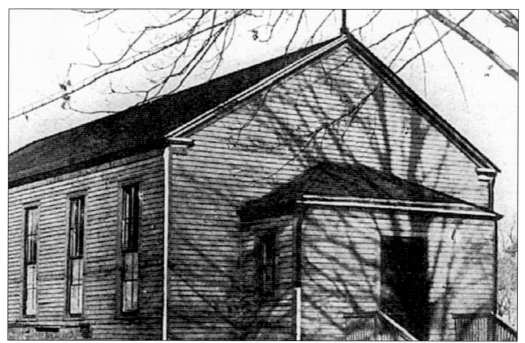

The west-side neighborhood was still rural in 1898, when Bishop McQuaid had this mission chapel built on the corner of Chili Avenue and Hobart Street. Dedicated as St. Augustine's, it was also used as a school for 23 children, mostly from the Lincoln Park Tract. The chapel/school had benches that could be removed when mass was held. Sisters of St. Joseph staffed the school.

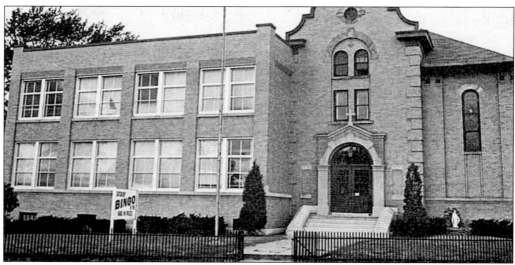

When fire damaged the original chapel/school in 1906, Bishop McQuaid approved plans for a larger structure to accommodate the growing neighborhood. Fr. John H. O'Brien was the first pastor. The new building, dedicated on July 8, 1907, had ample church space and much better school accommodations. As the parish grew, the campus expanded. A new church was erected in 1924; a new convent was completed in 1949; and in 1952, the school annex to the left of this 1907 church was added.

Residents along prestigious Chili Avenue eagerly awaited completion of the beautiful new St. Augustine's Church. Although Protestants were predominant in the neighborhood, with the new church it became clear that the Roman Catholics were here to stay, and tensions lessened. In 1938, on the occasion of the parish's 40th birthday, parishioners surprised their autocratic but much-admired Father O'Brien with the purchase of three bells cast at the McShane Bell Foundry Company of Baltimore. The largest of the three had a cross. With its mounting supports, it weighed 2,700 pounds.

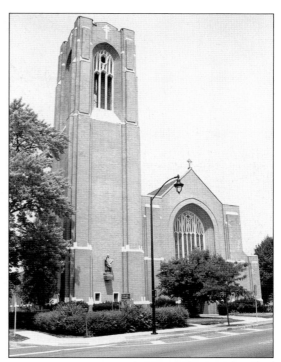

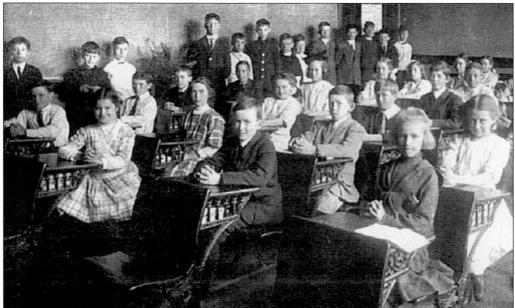

In this 1912 classroom photograph, St. Augustine fifth graders sit dutifully with hands placed on desks. Note their proper attire. The school often surpassed state educational requirements. Part of the church's agenda was to lessen tensions with the Protestant population. Quietly, the church saw to the poorest in the neighborhood, providing food, clothes, and coal in the winter. Many children—from both rich and poor families—were so impressed by their religious leaders that they chose to become priests or nuns.

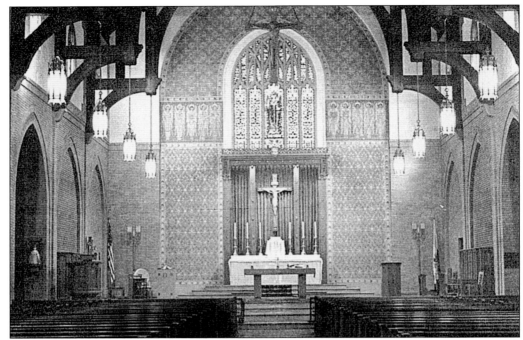

Only Rochester craftsman were to work on the new church. The architect, James Burns Arnold, grew up on West Avenue and trained under Claude Bragdon. The magnificent new church included a soaring Gothic nave, a Botticino marble altar, Tennessee marble floor, and oak pews. Pike's Stained Glass Studios in Rochester, whose founder worked in New York's Tiffany Studio, created the beautiful stained-glass windows. The nearly 200 Portuguese church members who resided in the Lincoln Park neighborhood purchased the first window.

A rather ambitious fair was held in the duplex church/school in May 1907. The weeklong affair included entertainments and shopping booths with merchandise donated by Sibley, Lindsay, and Curr and other prominent merchants.

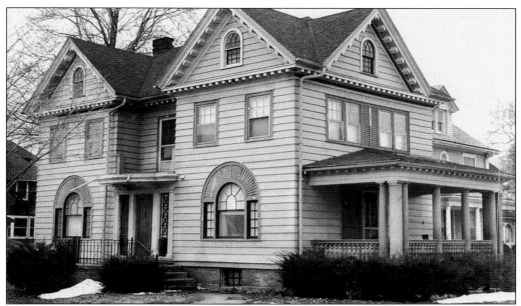

The original owner of this Colonial Revival at 305 Chili Avenue was Walter R. Morgan, a partner in the firm Rabbet and Morgan. Doctors, lawyers, professors, and other professionals were proud to make the stately west-side avenue their home when sentiments still suggested east-side neighborhoods were the place to be. This home is laid out in an H plan and is noted for its elaborate dentiled cornice, round arched windows with wood tracery, and impressive entryway. (Courtesy Landmark Society of Western New York.)

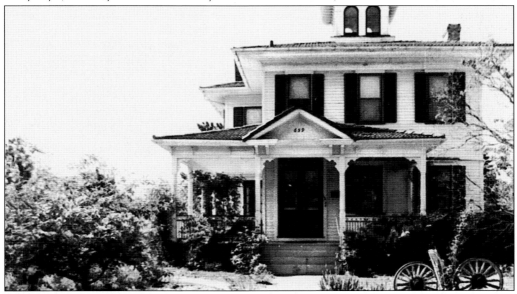

This Italianate, located at the corner of Chili Avenue and Turner Street, was likely a farmhouse. One of the more distinct homes, it was probably constructed somewhere between 1850 and 1880. The area was totally rural then. The surrounding neighborhood emerged from 1900 to the 1930s. This home was noted for its impressive gardens including a profusion of roses and a front gate fabricated from an iron wagon wheel. (Courtesy Landmark Society of Western New York.)

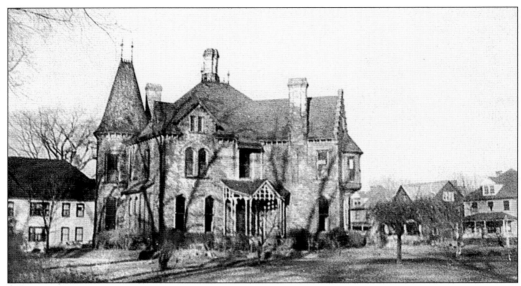

Henry Lester sold stoves, furniture, and hardware at his store at 156 West Main and owned this residence at 520 West Avenue, on the northeast corner of West Avenue and Colvin Street—technically Dutchtown. It eventually stood vacant, overgrown, and vandalized for years. Children hurried past because it was supposedly haunted. The Lester home was demolished for a supermarket. (Courtesy Landmark Society of Western New York.)

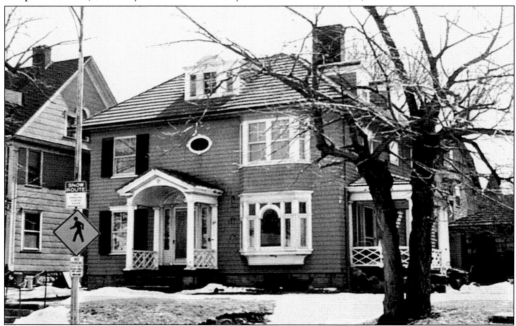

Architect Claude Bragdon designed 55 West Avenue for Mr. and Mrs. Herbert J. Stull in 1900. Herbert and his brother John, who lived next door, were partners in the Stull Brothers law firm. The residence features a typical Bragdon touch: a window set within a window. Other notable features are the classical entry porch with columns, Palladian motif trim, and the entry with its overhead fan and flanking sidelights. (Courtesy Landmark Society of Western New York.)

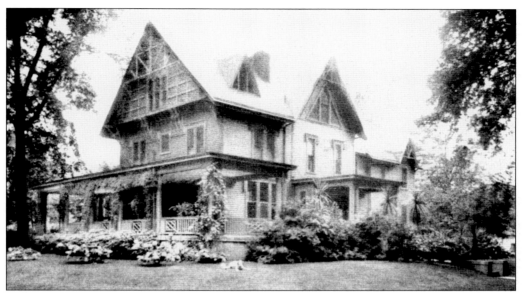

The C. F. Wray residence on West Avenue was later extensively remodeled as a funeral home (see *Rochester's Dutchtown* for further discussion of this area).

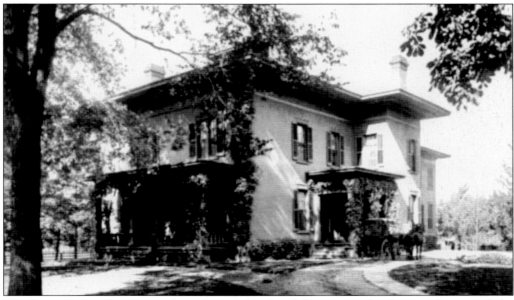

The Lewis P. Ross house stood on the north side of the avenue. It, along with most of the surrounding homes, was demolished when Lincoln Park, originally a planned park, was later designated industrial. Ross was a wholesale boot and shoe dealer. (Courtesy Rochester Public Library Local History Division.)

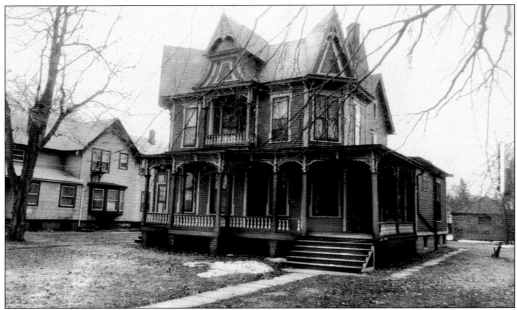

The Goler residence on West Avenue is a fantastic Queen Anne with gables, recessed porch, fretwork, and gingerbread. Fanciful and original, it was built for Dr. George Goler, a highly regarded public health physician who worked to provide, among other improvements, milk stations with pasteurized milk for schoolchildren. The University of Rochester named its large residence building Goler House in his honor. Goler Alley runs behind the residence. (Courtesy Landmark Society of Western New York.)

Dr. George Goler, born in Brooklyn in 1864, moved as a young man to Rochester, where he achieved renown as a dedicated physician, being appointed medical inspector of the Rochester Board of Health in 1892. His West Avenue residence is pictured above.

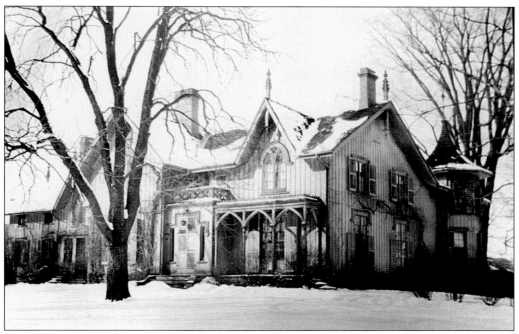

West Avenue's Danforth House is the city's most outstanding example of a surviving Gothic Revival–style residence. It was built about 1840 for Judge George F. Danforth and his family. Mrs. Danforth later gave it to the city, and in the 1950s, it was converted to the Danforth Recreational Center and a home for seniors. Many neighborhood children made use of the ice-skating rink behind it. (Courtesy Landmark Society of Western New York.)

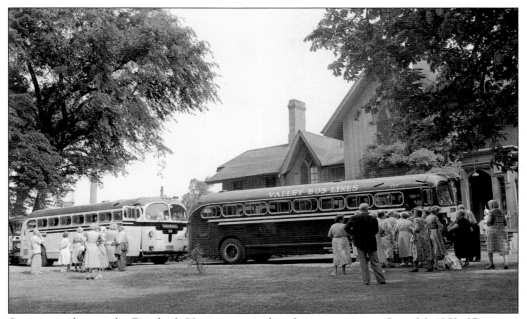

Seniors residing at the Danforth House prepare for a bus excursion on June 26, 1952. (Courtesy Rochester Municipal Archives.)

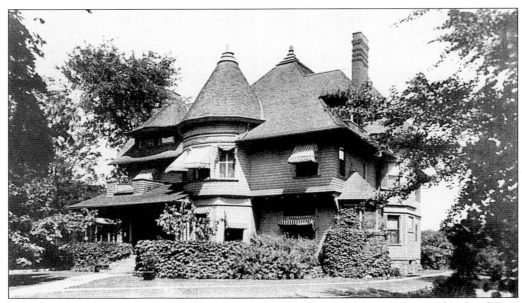

This impressive residence was built for Horatio and Charlotte Graves on the north side of West Avenue. It barely averted an appointment with the wrecking ball in the 1980s, being saved by preservationists. The massive Queen Anne–style home was moved up the avenue to a lot across the street and restored by the Junior League of Rochester.

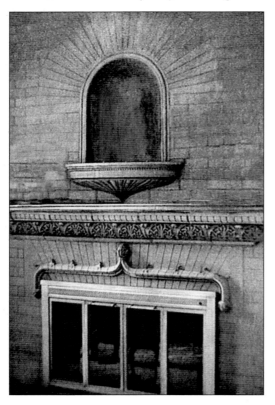

Exquisite craftsmanship is exhibited throughout the residence, as can be seen in this carved and cast-stone fireplace.

The grand staircase, lit by an overhead stained-glass dome, descends gracefully to the foyer.

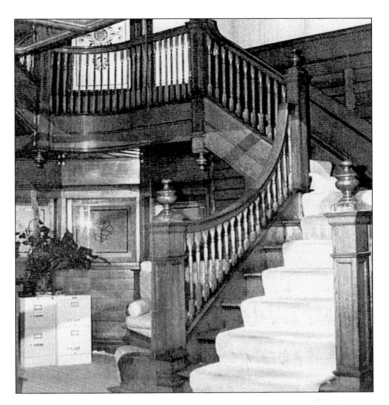

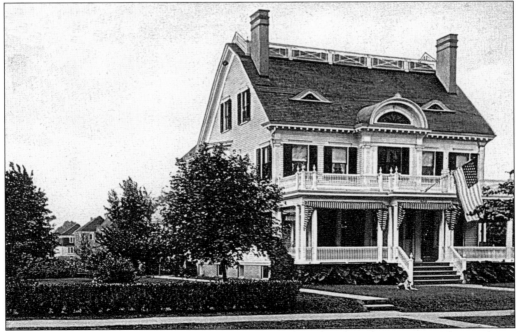

A 1906 postcard view shows the H. B. Guiford residence at 623 West Avenue on the southeast corner of Gardiner Park. Guiford owned two drugstores.

Built in the 1840s by Judge Addison Gardiner, this Gothic Revival–style manse would later be known as Fagan's Plantation. It is a sister house to the Danforth residence, pictured on page 79. Gardiner and Danforth were among Rochester's most prominent citizens, and their rural homesteads became favorite stops for the social elite. (Courtesy Rochester Museum and Science Center, Albert R. Stone Negative Collection.)

Occupying the former site of the Gardiner homestead, Gardiner Playground continues to serve the neighborhood.

Five

LINCOLN PARK MEMORIES

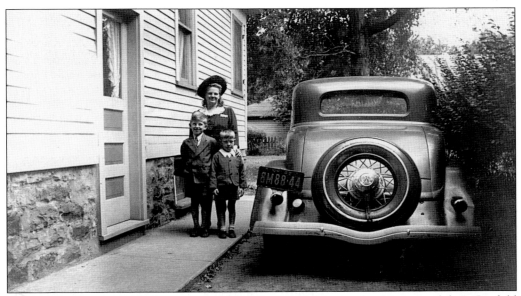

Florence Panke poses with her two sons, Karl (left) and Fritz, in the driveway of their Garfield Street home in the early 1940s. Garfield Street was in Lincoln Park, a 30-acre subdivision donated by D. D. S. Brown in 1883. Intended as part of a park system to be connected by a string of curving boulevards surrounding the city nicknamed "the Emerald Necklace," it would, instead, be designated industrial/residential in the 1890s. The area was bounded by West Avenue, Buffalo Road, Gardiner Avenue, and Chili Avenue. The German, English, and Irish settlers would later be joined by Italians, Portuguese, and African Americans. Children growing up here were not wanting in places to explore. There were abandoned foundries, the railroad yard, Gardiner Playground, brickyards, Chili Woods, the Barge Canal, and with a moderate bike ride, the Genesee River. (Courtesy Noeme Panke.)

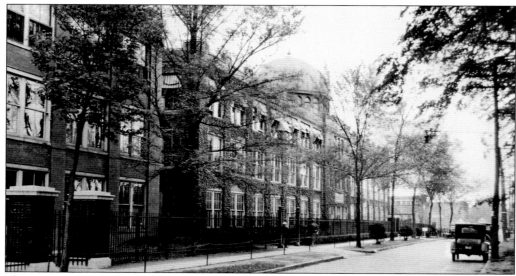

The green copper-clad dome of Taylor Instrument was a reassuring landmark. By 1910, it was employing 800 skilled workers, which fueled the economic vitality of Lincoln Park. The factory was located on the north side of West Avenue—technically in Dutchtown. (Courtesy Rochester Public Library Local History Division.)

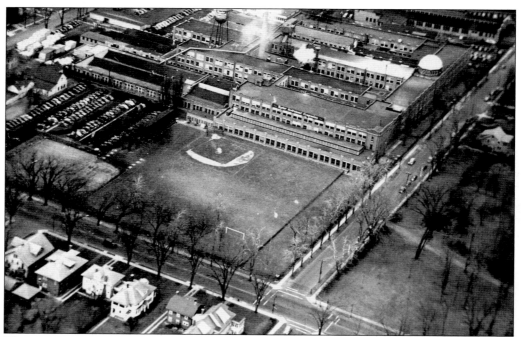

This 1930s aerial view of the Taylor Instrument Company shows the expansiveness of the West Avenue facility. The baseball diamond and athletic field were the site of many happy neighborhood gatherings. (Courtesy Rochester Public Library Local History Division.)

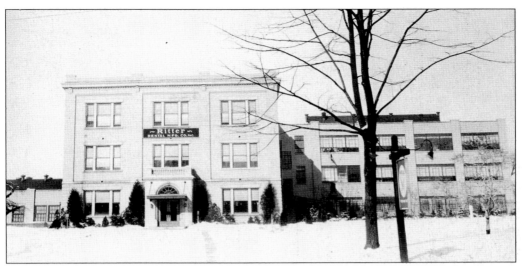

When the Ritter Dental Manufacturing Company moved to Lincoln Park in 1908, the area was still an industrial suburb. It was annexed from Gates in 1919 by the city, which provided services such as sewers, water, and police protection. Ritter would double in size by 1914, employing over 600 workers. Nearby industries included American Laundry and General Railway Signal. In 1908, the T. H. Symington Company moved from Corning to Lincoln Park. The Buffalo, Rochester, and Pittsburgh Railroad (later the Baltimore and Ohio) would also provide employment for the neighborhood. (Courtesy Rochester Public Library Local History Division.)

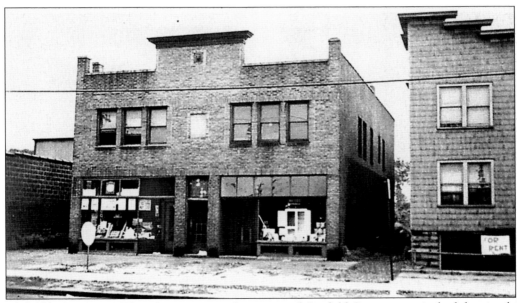

This old store across West Avenue, near the corner of Garfield Street, is typical of the simple architectural styles of Lincoln Park. To the right is an old apartment building. The front stairs led down to a basement printing shop, where two gentlemen ran large mechanical printing presses. Youngsters would stand in the doorway and watch the presses operate. Often they asked, "Any extra paper?" and if they were polite, they might get a few pads. (Courtesy Rochester Municipal Archives.)

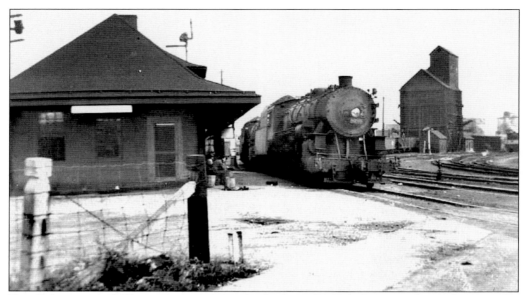

Two Baltimore and Ohio engines sit outside the Lincoln Park depot in the mid-1930s. The surrounding yard was established by the Buffalo, Rochester, and Pittsburgh Railroad. In 1882, the company built a 14-stall roundhouse and turntable. Adjacent engine facilities included water, coaling, and sanding towers. The depot came down in the early 1990s. (Courtesy New York State Museum of Transportation.)

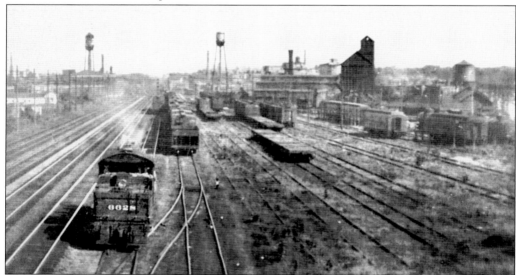

This 1939 view of the Baltimore and Ohio Railroad yard at Lincoln Park, taken from the pedestrian bridge, shows the coaling tower, passenger car yard, water tower, and (barely visible) the roundhouse where steam engines were serviced. Many residents along West Avenue and its side streets worked for the railroad and were therefore tolerant of sooty morning air, the clanging of couplers as trains were arranged throughout the night, and the pall of steamy smoke that the massive yard generated. The yard was developed by the Buffalo, Rochester, and Pittsburgh Railroad. In 1932, it was merged into the Baltimore and Ohio. (Courtesy New York State Museum of Transportation.)

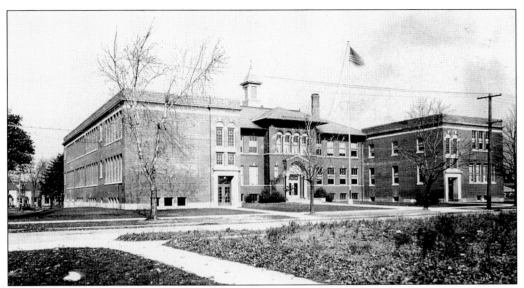

Lincoln Park School No. 44, shown here in 1935, was built in 1913 on the corner of Chili Avenue and Stanton Street. Known as Gates then, the area was mostly farmland extending west of the school. Previously, the neighborhood had been served by a small school on the corner of Chili Avenue and Gardiner Park. The city annexed this part of Gates in 1919. (Courtesy Rochester Public Library Local History Division.)

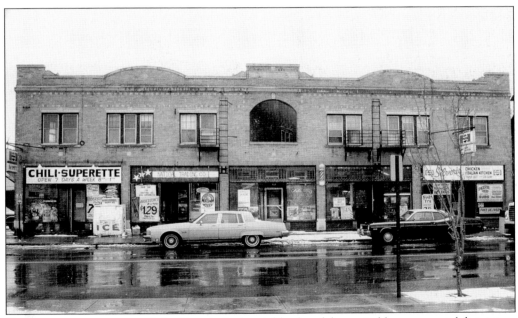

Corner grocery stores served the Lincoln Park neighborhood, but a sizable commercial district on Chili Avenue included grocers, bakeries, liquor stores, a movie house, Laundromats, pharmacies, and a few taverns. This commercial block, pictured in the 1980s, is near the corner of Chili Avenue and Thurston Road. Near this spot, students burned in effigy a life-sized figure of Hitler when victory in Europe was announced.

Gail Panke poses in front of her Garfield Street house in the 1950s, surrounded by the majestic elms later lost to blight. She made trips with her friends to neighborhood grocers like Mary's on Lincoln Avenue and Reynold's on Depew Street. She bowled at Perry's and attended Friday night dances at Gardiner Playground. Neighborhood characters included "Crazy Emily"; "Little Charley," who sold lemonade; and "Old Mary," who supposedly kept her husband's casket in the attic and prayed over it at night. At dusk, kids would sit on the front steps and play "Movie Stars," mimicking an actor until someone guessed who it was. The child who answered correctly then had to chase the actor around the light post and try to tag him. (Courtesy Noeme Panke.)

Florence Panke and her sons, Karl (left) and Fritz, are pictured here in the early 1940s. The Pankes were of German descent. Interestingly, the neighborhood had a large Portuguese colony—mostly from the Madeira Islands. They began arriving shortly after 1909 to work for the T. H. Symington Company, a foundry that produced railroad equipment. (Courtesy Noeme Panke.)

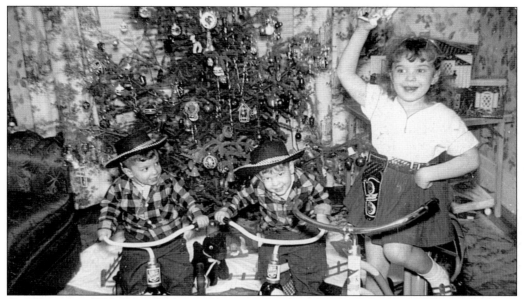

On Christmas 1956, Diane Leavy and her twin brothers, Michael (left) and Glenn, enjoy new bikes in their Garfield Street home. Their brother Arthur would arrive a year later. Michael and Glenn (the authors of this book) would become little devils—hopping trains, starting bonfires, climbing along the girders of the Barge Canal Bridge, swimming at Chili Woods, and discovering the abandoned factories and foundries. They left no inch of Lincoln Park unexplored.

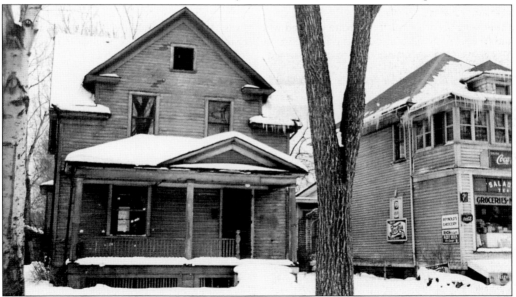

This style of home on Depew Street was to Lincoln Park Ward what the American Foursquare was to the 19th Ward north of Chili Avenue. These modified Cape Cods had roomy attics, large front porches, and nice basements where many boys put up tables to run their Lionel trains. To the right in this post–Depression era image is Reynolds's Grocery, a favorite stop for pop and candy. Mr. Reynolds was strict and would not sell beer. Bob Reynolds operated the store after his father's death. (Courtesy Rochester Municipal Archives.)

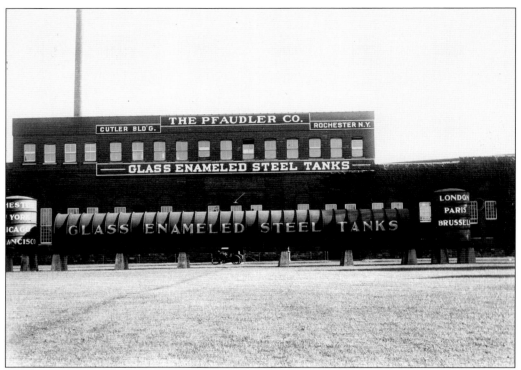

The Pfaudler Company, shown around 1915, was another major employer. Among its products were glass-enameled tanks used primarily in railroad refrigerator cars. Items manufactured at Lincoln Park factories were sold worldwide. (Courtesy Clay Gehring.)

Pictured in 1965, The "Shanty" at Gardiner Playground was a great place for games, crafts, and Friday night dances. (Courtesy Rochester City Hall Photo Lab.)

Six

THURSTON ROAD

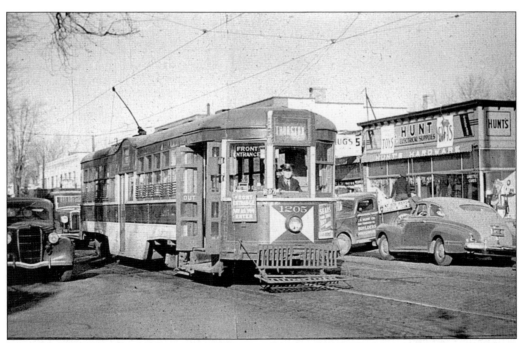

Streetcar No. 207 makes its last run up Thurston Road in 1940. The street is bustling, as Hunt's Hardware readies for the holiday season with banners advertising gifts and toys. As car ownership increased, streetcars became more of a nuisance, and the track and overhead wiring needed constant maintenance. Buses were also supplanting them as a form of mass transportation. Thurston has always been the ward's commercial lifeline. Once filled with bakeries, barbershops, markets, theaters, and restaurants, it has also provided the ward with its small-town flavor. (Courtesy Hunt's Hardware.)

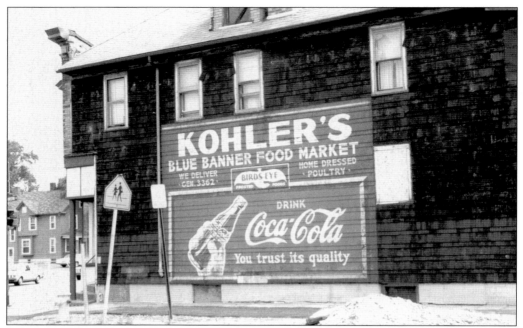

When asphalt siding was stripped from this building at the corner of Chili Avenue and Thurston Road in the early 1980s, an original hand-painted billboard was discovered. It made the evening news, and an artist was brought in to touch up this interesting slice of Americana. Kohler's offered brand names like Coca-Cola and Birds Eye Frosted Foods as well as its own Home Dressed Poultry. The structure has since been demolished and a community garden installed.

The Rochester Presbyterian Home has provided services for seniors since 1927. The large center portion of the facility (North Hall) was originally the residence of Thomas and Mary Dunn. Mary later donated it for use as a home for retired ministers and their wives. Benefactors included Irving T. Clark, M.D., Alva Strong, and David and Margaret Nivins. The home continues as one of the three anchors of Thurston Road, the others being the Megiddo Mission and Hunt's Hardware facility.

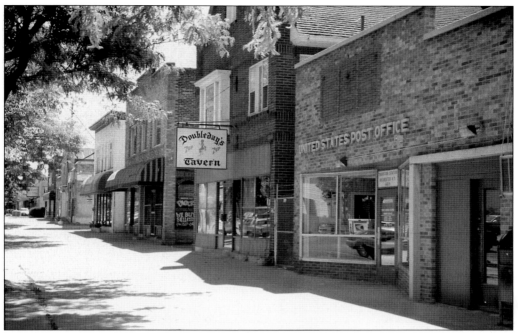

This commercial block includes the ward's post office and Doubleday's Tavern, a favorite sports bar. Other watering holes were Murphy and Nalleys, the Turn-in Tavern, Chili Inn, and nearby Cross Keys. (Courtesy Rochester City Hall Photo Lab.)

Inglewood Drive remains one of the most beautiful streets in the ward. Running between Genesee Park Boulevard and Thurston Road, it is a restful stretch of broad lawns, tall trees, and fine homes.

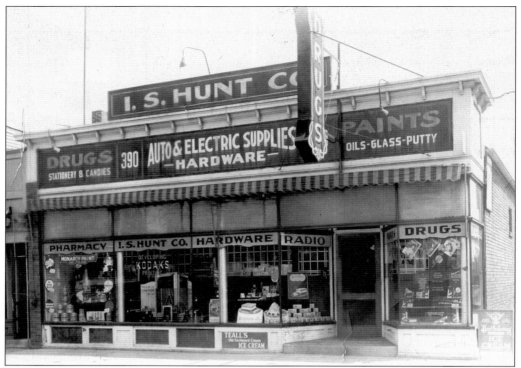

A stop at Hunt's Hardware in 1925 was rewarding for parents and children alike. The large display windows were attention-getters. Kodak film could be dropped off for printing. If one's RCA radio was on the blink, Hunt's carried replacement tubes and even repair parts for Stromberg Victrolas. Aside from the more mundane necessities like nails, mousetraps, and mothballs, there were the popular magazines of the day. For the young ones, the big decision was either Bartholomay or Teall's ice cream. (Courtesy Hunt's Hardware.)

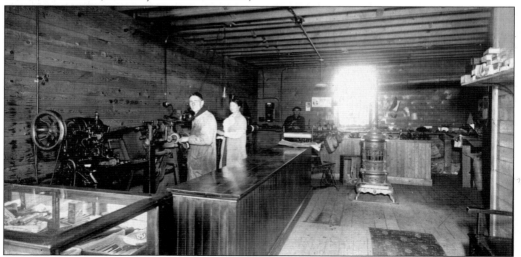

Workers operate machinery at Tom Sawley's shoe repair shop at 384 Thurston Road in 1918. Note the wood-burning stove at the rear of the shop and the display case to the left offering products for the proper care of footwear. (Courtesy Hunt's Hardware.)

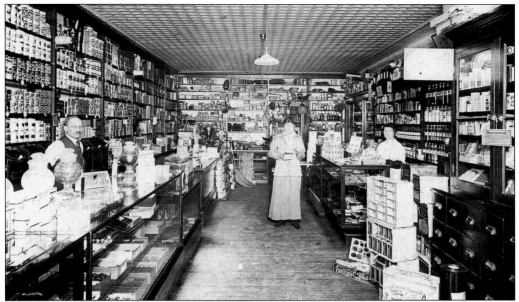

The original Hunt's store opened in 1914 in what would become the dining room of Reynold's Lanes. Pictured here are founder I. S. Hunt (left), customer Evelyn Harder (center), and employee Ellen Jacques. Hunt's daughter Gladys Smith would work here in her teenage years. She recalled, "I used to work at the old store at the Reynold's location on weekends. My dad had the small store packed with groceries on the right, drugs on the left, and hardware to the rear. You'd walk out the front door and there were the trolley tracks, smack in the dirt. The old trolleys seem romantic today, but it was a real mess to look at when things got wet!" (Courtesy Hunt's Hardware.)

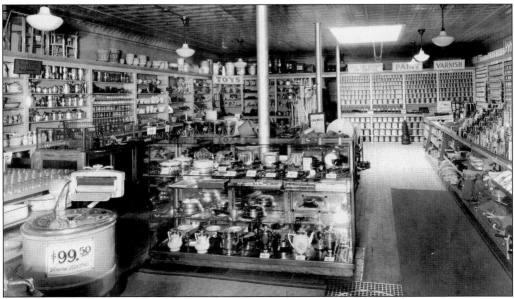

Hunt's Hardware is packed with household goods, toys, and other merchandise such as kerosene heaters, paint, canning jars, kitchenware, coffee percolators, and even General Electric clothes washers in this 1925 image. To the left is a small post office counter. (Courtesy Hunt's Hardware.)

Harryette Toothill Lux stops in front of Hunt's old 366 Thurston Road site. Harryette would work for Hunt's during the Great Depression. Of that time, she remarked, "People thought we were crazy to move out here in the 'country' where there were dirt roads with no lights, but Hunt's was a nice country store." In the background is the Thriftway Grocery, where the Toothills lived upstairs. (Courtesy Hunt's Hardware.)

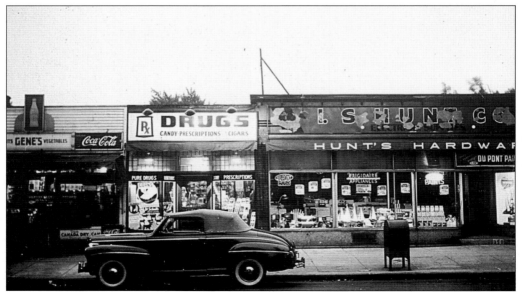

A twilight photograph taken during the Great Depression shows the commercial block that included Hunt's Hardware and its separate drugstore. (Courtesy Hunt's Hardware.)

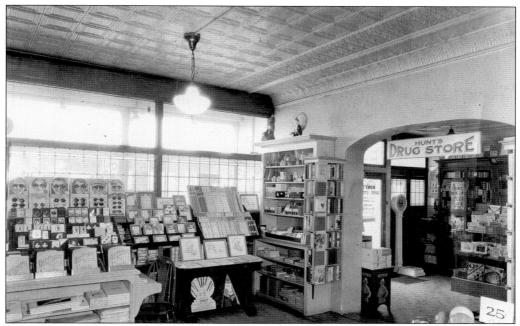

The tin ceiling in this 1928 interior view is still a feature of the store today. At Hunt's, customers could browse the selection of cigars and cob pipes. Children could rush to the toy counter, where prices started at 10¢. There were shelves with giftware, candles, and stationery. (Courtesy Hunt's Hardware.)

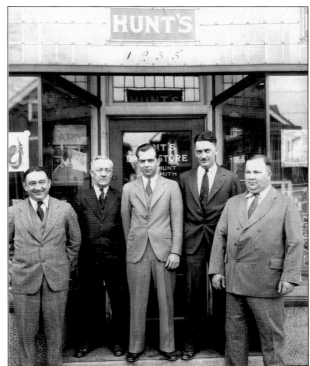

Proprietors and employees of Hunt's Hardware and Hunt's Drug Store on Thurston Road pose in the doorway of the drugstore in 1935. Hunt's has been a mainstay of the neighborhood almost from it beginning. (Courtesy Hunt's Hardware.)

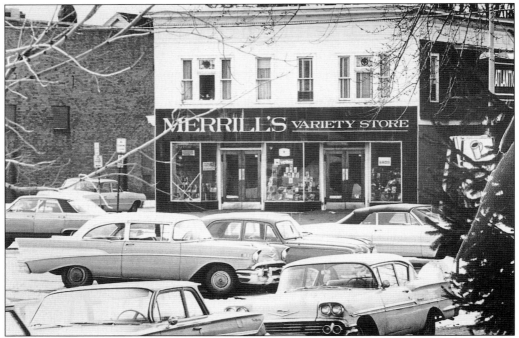

Flashy cars bring back the excitement of Thurston Road in the 1950s and 1960s, and Merrill's was a big part of that. Paperboys hoped for extra tips so they could buy motors for their Estes Rockets. Dads brought their Boy Scout sons here to get their racer kits. Girls came for party supplies, makeup, and dollhouse furniture. Mom searched out baking pans and kids' school supplies. And Dad grabbed a few quarters out of the car ashtray to buy a cigar. (Courtesy Hunt's Hardware.)

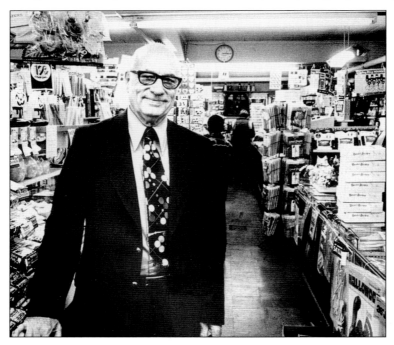

Mr. Merrill stands proudly within his dense inventory of toys and trinkets as Willie Wonka might stand in his chocolate factory. There was no place like Merrill's for a child with a pocket full of change. Besides toys, the shop sold bubble gum, Testor's paints for kids' models of the Creature from the Black Lagoon, Halloween masks, makeup, cap guns, games, and art supplies. (Courtesy Hunt's Hardware.)

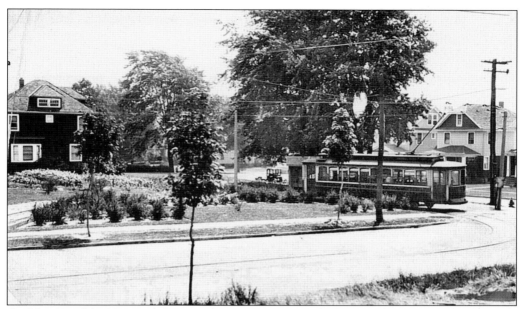

Car No. 424 of the New York State Railway System enters the loop at Thurston Road and Brooks Avenue on its Arnett-Clifford route. This site is now a parking lot for a Rite Aid Pharmacy. (Courtesy New York State Museum of Transportation.)

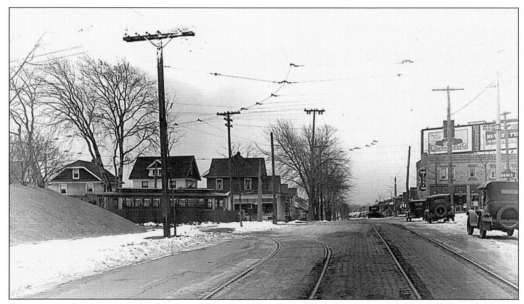

A streetcar heads into the loop at Thurston Road and Brooks Avenue in 1930. Louie's Sweet Shop is to the right. Note the overhead wiring and trolley poles. In time, residents who originally chose the ward because of its streetcar service would come to find the utilities needed to support the system unsightly. (Courtesy New York State Museum of Transportation.)

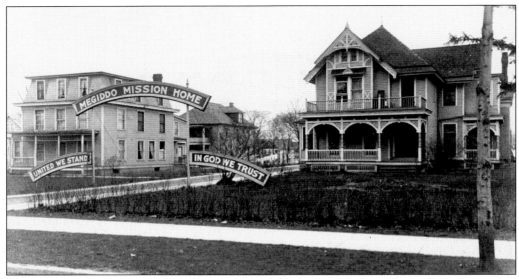

The Megiddo Mission was founded in the South by L. T. Nichols in the early 20th century. He conceived an idea of spreading his message by cruising the Mississippi, the Ohio, and their tributaries in a steamboat. On January 25, 1904, his missionaries boarded a train for Rochester, where they had purchased five acres on Thurston Road. The mission history stated that a "handsom residence & two cottages" formed the nucleus of their new mission home. These "zealous Christian workers" quickly expanded their campus with a three-story building and other cottages. This image dates from about 1916. (Courtesy Hunt's Hardware.)

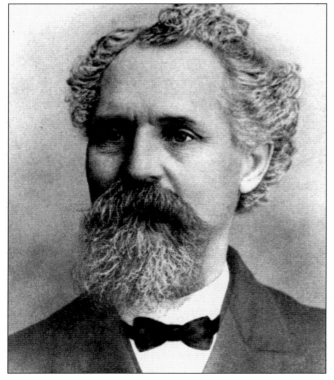

L. T. Nichols (1844–1912) was a successful manufacturer near Minneapolis when strong spiritual yearnings made him take steps toward the establishment of a mission. He decided that through a boat, he could reach as many people as possible. Raising money, Nichols then built the *Megiddo*, a 205-foot-long, three-deck steamboat, to spread his message in southern waterways. (Courtesy Megiddo Mission Church.)

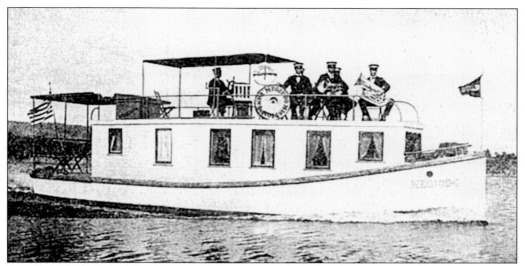

The idea of evangelizing by boat did not change when the group came to Rochester. The yacht *Megiddo II* cruised upstate New York waterways for a year. The *Megiddo III*, a 40-foot vessel, was then acquired. During the 1920s, "Gospel Marines" brought their message—and music—to local towns. The vessel was a beautiful sight on the Barge Canal, Genesee River, and other lakes and waterways in New York State. (Courtesy Megiddo Mission Church.)

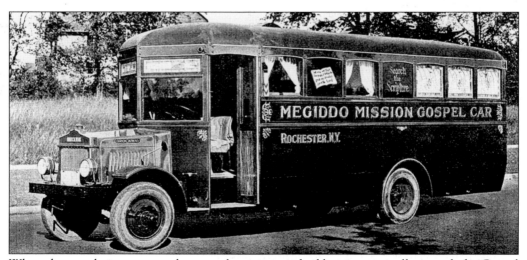

When the population centers along nearby waterways had been pretty well covered, the Gospel Marines hit the road in this "Gospel Car," built by the missionaries on a two-and-a-half-ton truck chassis. (Courtesy Megiddo Mission Church.)

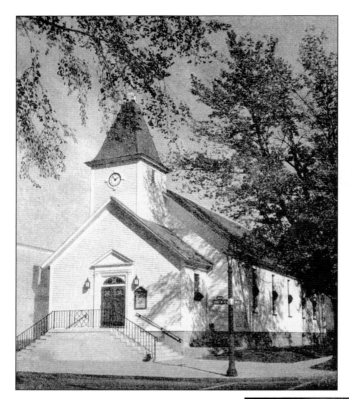

The congregation's mission chapel was built on the corner of Thurston Road and Sawyer Street, an area where missionaries would build a number of homes. It was dedicated on March 22, 1908, and continues to serve the congregation today. This photograph dates from the 1930s. (Courtesy Megiddo Mission Church.)

Rev. Ella M. Skeels (1858–1945), the founder's youngest sister, assumed leadership after the passing of Rev. Maud Hembree. For 10 years—including the difficult years of World War II—she led effectively and with singleness of purpose. (Courtesy Megiddo Mission Church.)

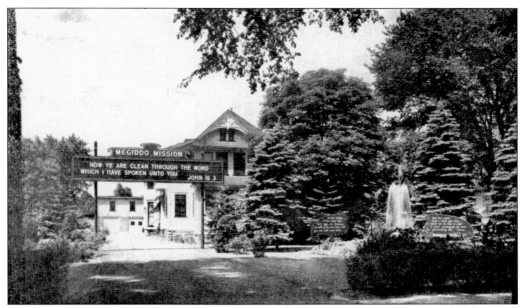

The main entrance to the Megiddo Mission grounds, always beautifully landscaped, includes a fountain. The mission remains one of the most picturesque places in the ward. (Courtesy Megiddo Mission Church.)

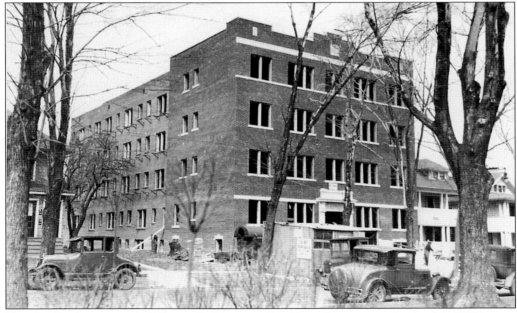

The Apollo Apartment building at 81 Thurston Road is under construction in this 1928 image. It was destroyed by fire in 1994 and razed in 1997. (Courtesy Rochester Public Library Local History Division.)

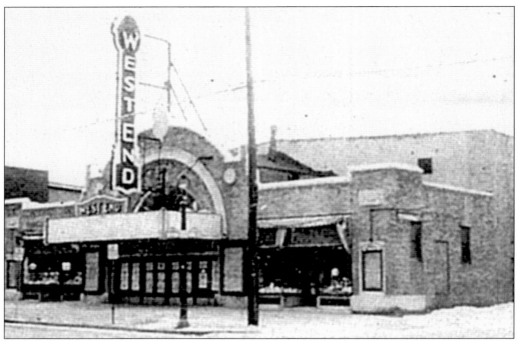

The West End Theater (later the Cornet) stood at the corner of Thurston Road and Midvale Terrace, just a short walk from Merrill's Variety Store and Louie's Sweet Shop. A bowling alley was located across the street just to the north. Farther north on Thurston was the Arnett Theater, and it was only a short streetcar ride down Arnett Boulevard to reach the Madison on Genesee Street. Kids with pocket money could ask no more of a neighborhood on a Saturday. The West End Theater was razed in the spring of 2005, and a park now occupies the site.

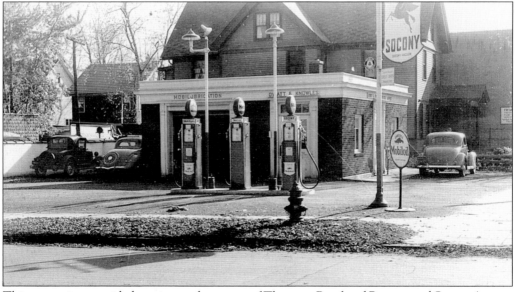

This gas station provided service on the corner of Thurston Road and Ravenwood Street. Among the cars parked are a 1929 Ford Model A and a 1937 Ford. (Courtesy Hunt's Hardware.)

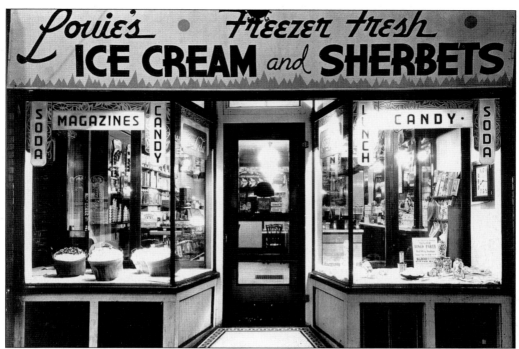

Louie's Sweet Shop was dazzling at night, as demonstrated in this 1938 image. The family-run business provided a comfortable place for young men to bring their dates for a malt, a 15¢ sundae, or homemade candies. When this 19th Ward icon closed in 1997, the old-fashioned ice-cream fountain and other vintage fixtures were removed and installed at the Strong Museum. Today museum visitors can continue to enjoy sweets as 19th Warders did for over two generations. (Courtesy Hunt's Hardware.)

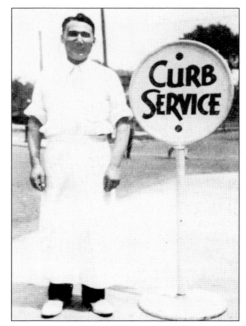

Louie Throumoulos stands proudly beside his "Curb Service" sign on the corner of Thurston Road and Brooks Avenue. (Courtesy Hunt's Hardware.)

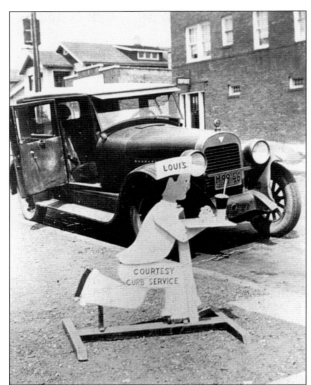

A car has pulled up on Thurston Road for a quick snack from Louie's curb service in the early 1930s. The sweet shop can be seen across the street, though, interestingly, the sign on the side door reads "Dentist." (Courtesy Hunt's Hardware.)

A student holding the American flag stands affectionately beside her teacher at Lewis Henry Morgan School on Congress Avenue around 1917. Kids moved west in eager pacts after school to enjoy the many delights Thurston Road offered—or at least to catch the trolley home. (Courtesy Rochester City Hall Photo Lab, Sneck Collection.)

Seven

GENESEE VALLEY PARK

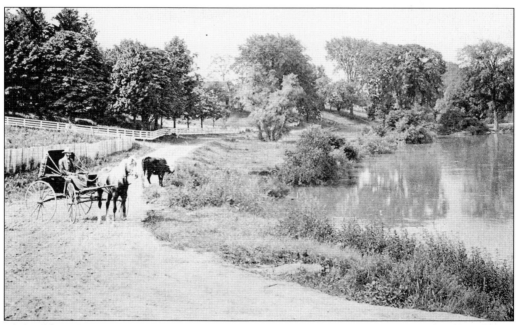

The public's increasing interest in outdoor recreation led to the emergence of a park system in 1888. Speculators and owners of farms along the Genesee River began to raise riverfront prices. South Park (later Genesee Valley Park) is pictured here in its early stages. Later noted landscape architect Frederick Law Olmsted would have many of the trees and farm buildings removed and thousands of new trees and shrubs planted to accentuate the rolling hills. Picnic groves would provide families pastoral solitudes to escape the grime of the city. Picturesque bridges spanning creeks and trails would allow for leisurely walks.

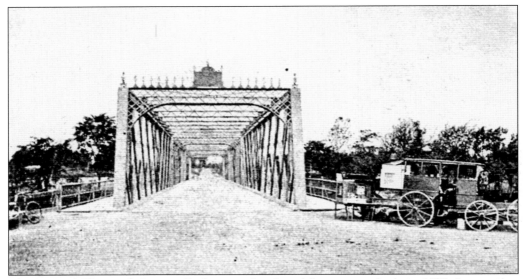

The original Elmwood Avenue Bridge was this fanciful iron truss built in 1888. Its opening spurred development of the ward and allowed park visitors to enjoy activities on both sides of the river. Longtime resident Mary Bricker Wilson recalls the bridge from her childhood days: "The wood planks were wide enough apart that you could see the river through them. It was scary walking across it." This image dates from about 1890. (Courtesy Rochester Public Library Local History Division.)

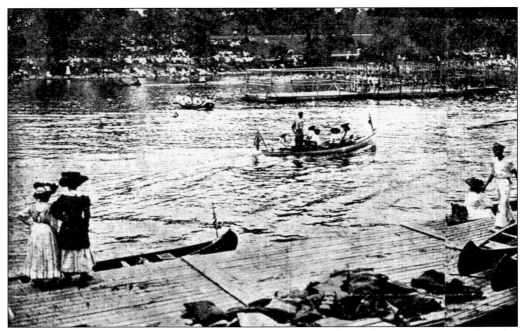

Trains, trolleys, and boats brought hundreds to Genesee Valley Park for water carnivals. This one, held around 1900, featured boat rides, fireworks, dances, regattas, concerts, and athletic events. At night, the Elmwood Avenue Bridge was lit with strands of lights. (Courtesy Rochester Public Library Local History Division.)

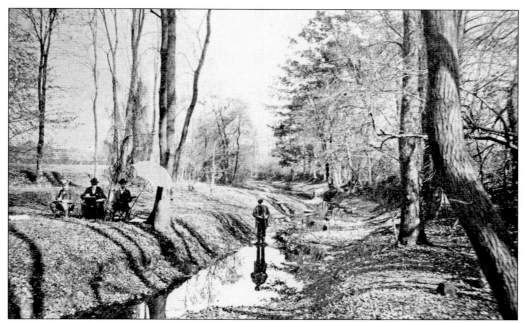

Artists apply their brushes to canvas in hopes of capturing the inspiring beauty of Genesee Valley Park around 1900.

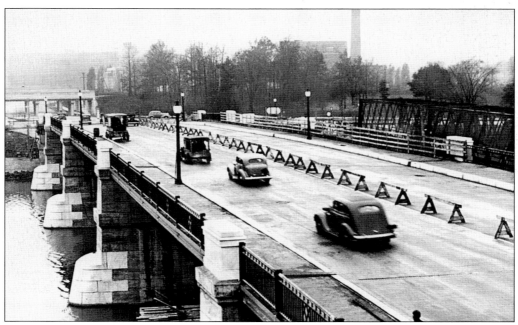

The impressive new Elmwood Avenue Bridge overshadows the original 1888 iron truss bridge, to the right in this 1930s image. (Courtesy Rochester Municipal Archives.)

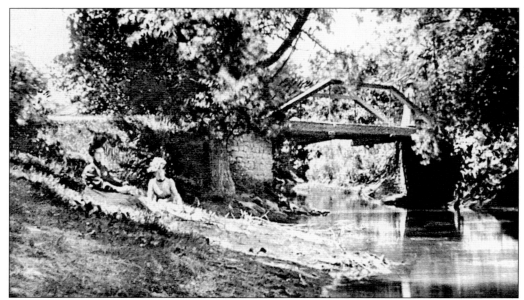

This pastoral scene at Genesee Valley Park's Red Creek dates from the early 20th century. Beyond its scenic beauty, the place has historical significance. A marker near the bridge explains, "Here was the western terminus of the Portage Trail from Irondequoit Bay to the Genesee. Its eastern end was the Indian Landing on Irondequoit Creek. It formed part of the Ohio Trail, famous in the early history of this country."

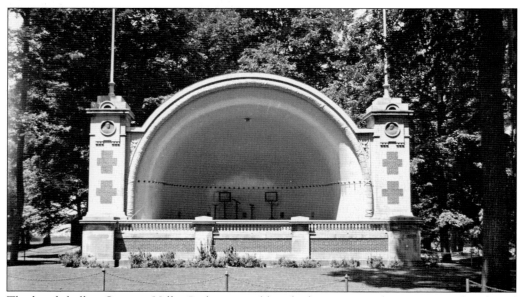

The band shell at Genesee Valley Park attracted hundreds to concerts by community bands and to other entertainments such as operas and musicals. Not all were dutiful listeners, however. Sometimes there were wicked boys about. An attendee of a concert in the 1940s recalls, "We were watching a concert performed by a small Italian band. Some boys came up out of the trees behind us and started pelting the band with apples. I can still see the poor old drummer's feet going up as he was knocked off his stool." (Courtesy Rochester Public Library Local History Division.)

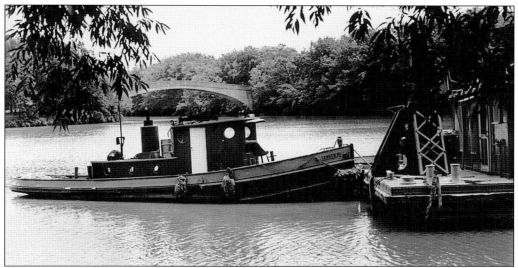

Tender No. 10, an old tugboat, nudges a barge down the Barge Canal where it intersects with the Genesee River. In the distance is one of Olmsted's graceful concrete bridges.

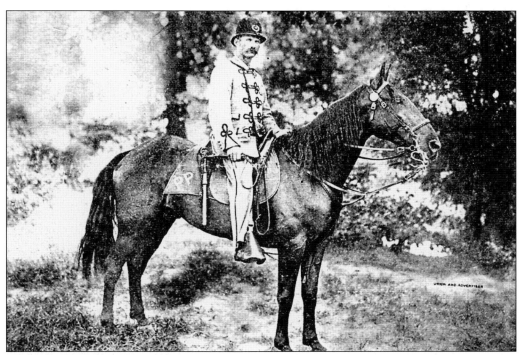

A mounted park police officer in vivid uniform patrols Genesee Valley Park in this *c.* 1893 image from the *Rochester Adviser.* The large park was designed with peaceful enclaves so families could relax and escape the congestion of the city, but plenty of activities occurred nonetheless. These included fox hunts, equestrian events such as races and polo tournaments, water festivals, carnivals, regattas, and concerts. The trolley loop at the end of Plymouth was always filled with visitors anxious to use the pool, trails, merry-go-round, athletic field, and, come winter, the ice-skating rink. (Courtesy Rochester Public Library Local History Division.)

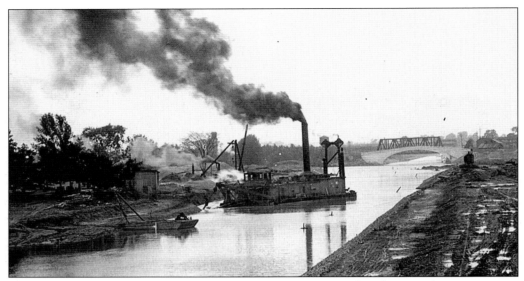

Built by the American Locomotive Company, the dredger *General Herkimer* performs operations on the Barge Canal near Genesee Valley Park. In this June 27, 1919, image, one of the Frederick Law Olmsted–designed arched bridges is visible. The river connected with the canal system near the park. Today the waterway has been renamed the Erie Canal and is used for recreation. (Courtesy Rochester Public Library Local History Division.)

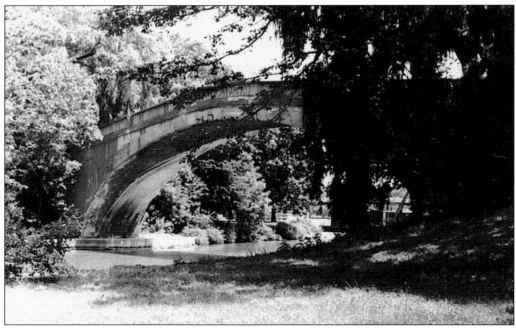

The park was adorned with beautiful arched bridges designed by Frederick Law Olmsted.

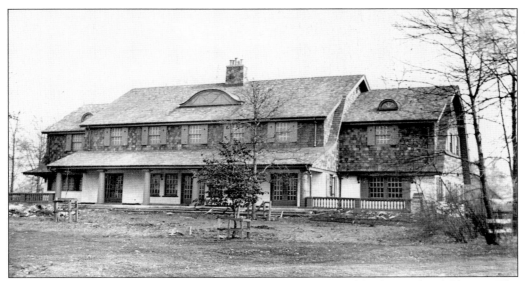

Patrons of the park's nine-hole golf course, laid out in 1898, could relax at the clubhouse. The park maintained a large municipal herd of sheep and ewes to keep the grass cropped. Horses and goats nibbled the grass to the ground, but sheep nibbled it to just the right length. (Courtesy Rochester Public Library Local History Division.)

Genesee Park Boulevard, one of the most picturesque in the city, was intended as part of the "Emerald Necklace," an ambitious plan to surround the city with a series of parks connected by residential streets. The boulevard curves gracefully to welcome visitors to Genesee Valley Park. Its north end was to intersect with the proposed Lincoln Park. Mount Read Boulevard was to be part of that plan as well. The plan was later abandoned.

The vivid illumination of small carnival rides, in the early days, combines with the soft glow of twilight in Genesee Valley Park in 1975. Two railroads—one on each side of the river—brought excursionists for a day's outing.

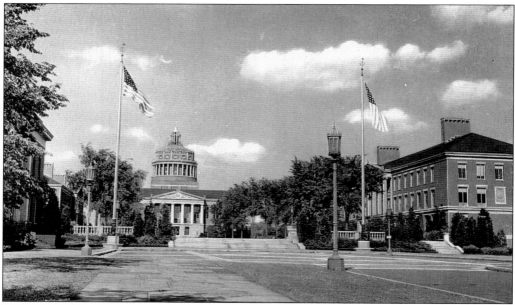

Located on the east side of the river, the University of Rochester has long dignified the ward, providing a stately vista to those strolling the park or cruising the river. The university acquired the former Oak Hill Country Club site in the late 1920s and began development of its new campus in 1930. (Courtesy Rochester Public Library Local History Division.)

Eight

A TOUR OF THE WARD

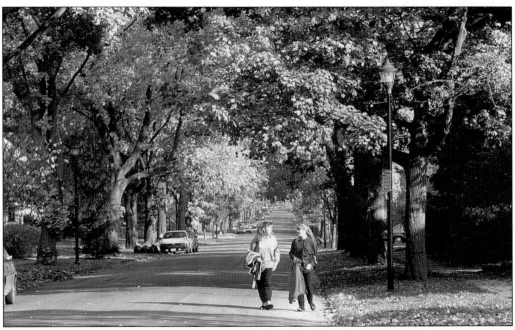

The 19th Ward has always been noted for its shady, tree-lined streets, fine homes, and family-based institutions. It has faced the same problems of many American cities: crime, neglect, and flight to the suburbs. But because of its strong neighborhood association and undying dignity, it has taken its knocks and remained vibrant. Churches continue to help, quietly providing support to those in need and even getting in the face of thugs who threaten the overall well-being of the community. Investments by the University of Rochester and the city have laid the foundation for a promising future. This chapter focuses on the ward's rich heritage. (Courtesy Rochester City Hall Photo Lab.)

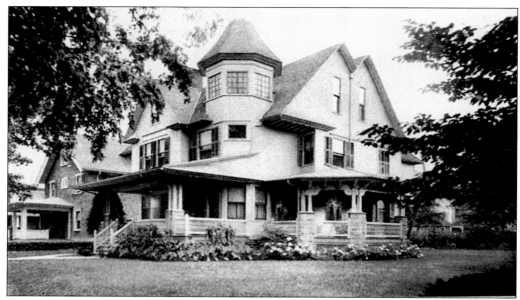

The ward's mansions, demonstrated here by the P. A. Vay house on Kenwood Avenue, rivaled those on the city's east side. The Vays were prominent in Dutchtown political and social matter before moving to the 19th Ward. (Courtesy Landmark Society of Western New York.)

During World War II, neighbors planted victory gardens such as the Myron Atkins Garden at 581 Sawyer Street. These gardens were also planted in school yards and churchyards. The purpose was to supply produce to families whose husbands and fathers were fighting overseas. (Courtesy Rochester Public Library Local History Division.)

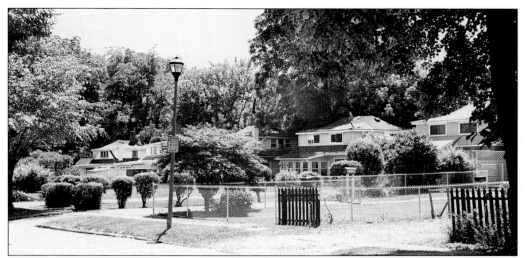

Oak Hill View, off Genesee Street, was an early-20th-century experiment in neighborhood living. Each home was a "bungalet," a single cottage set at the back of the lot to give a healthy rural feel. Each bungalet had many windows, including a single small one of leaded glass, and two upstairs bedrooms.

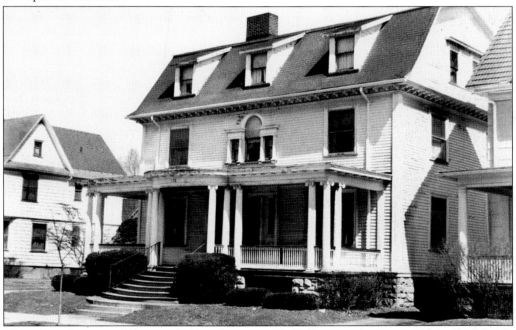

The original owner of this c. 1898 residence at 178 Wellington Avenue was Joseph Holm. It is described as a hybrid neo-Georgian with a Dutch Colonial Revival roof. The student of architecture and those just interested in their neighborhood's architectural heritage will note that the residence even contains neoclassical Revival details such as the porch columns with Ionic capitals. An impressive Palladian window adorns the street front. Note the brackets under the eaves. The interior of these homes often incorporated Waterford crystal chandeliers, ornate staircases, leaded and stained-glass windows, and tiled fireplaces. (Courtesy Landmark Society of Western New York.)

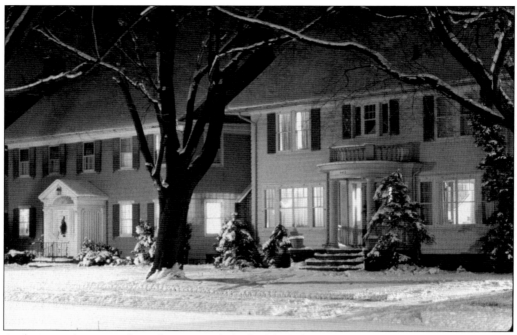

Architectural gems such as these graced the highly fashionable Sibley Tract, where craftsmen showcased their skills.

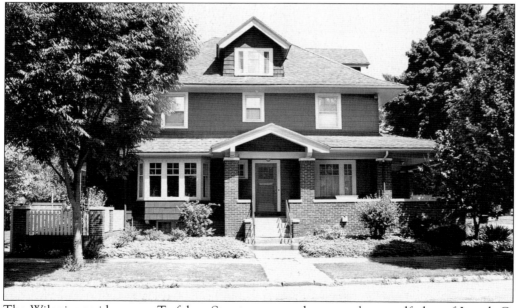

The Wilenius residence on Trafalgar Street was once home to the grandfather of Joseph C. Wilson II, who invested in an electric photography process that came to be known as xerography, which eventually broadened into Xerox. Mr. and Mrs. Wilenius have enriched the ward, operating the Creator's Hands for 25 years on Arnett Boulevard and now in the High Falls District.

Another streetscape captures the elegance of the Sibley Tract. Many homes located here featured chestnut trim, which became available in great quantities after a blight around 1900 required cutting the trees down—even the healthy ones. The wood was made available, in some cases for free, to carpenters. (Courtesy Rochester City Hall Photo Lab.)

Holiday lights illuminate a winter's night with a festive glow. Up until the 1970s, residents did not have to venture far to get fresh-cut Christmas trees. Boy Scouts sold them at the West Avenue Methodist Church, as did grocery stores and even a few gas stations along Thurston Road and Genesee Street. (Courtesy Rochester City Hall Photo Lab.)

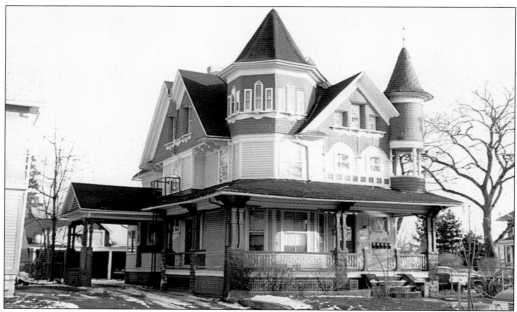

One of the more elaborately detailed Queen Annes in the 19th Ward stands at 244 Kenwood Avenue. Built in the Hawthorne Terrace Tract for Miles Lindsay about 1900, it was later acquired by Sylvester Beardsley, a butter and egg merchant who would live here from 1904 to 1920. In 1933, the home was divided into three apartments and then six in 1960. It is beautifully adorned with towers, a unique double gable, brackets, turned spindles, stone piers, wavy shingling, finials, and a porte cochere, or carriage port, as they are more commonly known.

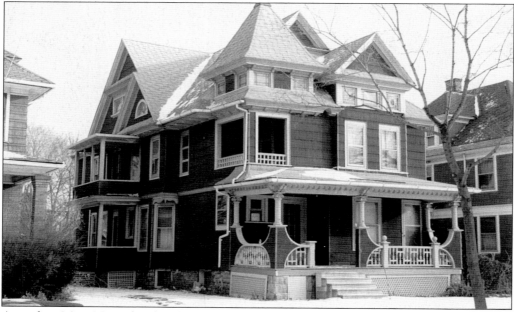

A teacher, Mary Niven lived with her sister in this Queen Anne at 46 Kenwood Avenue from 1901 until well into the 1930s. The railings of its inventive porch have a Japanese influence, and the square tower includes a recessed porch and a crocketed finial.

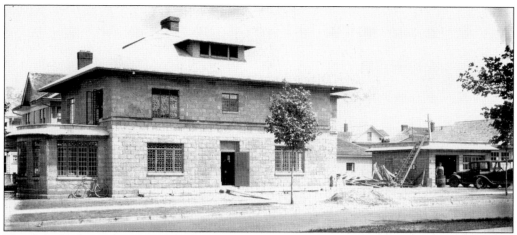

The Odenbach residence on Woodbine Avenue is one of the most distinct in the 19th Ward. Mrs. Odenbach was careful in her design. Her fear of fire led her to build the house with no wood in the interior; even the trim around the doors and windows is metal. The house had an elevator and a fishpond in the solarium. The Odenbachs were successful entrepreneurs in both the shipping and restaurant businesses. This image, showing the residence under construction, was taken between 1910 and 1920. (Courtesy Rochester Municipal Archives.)

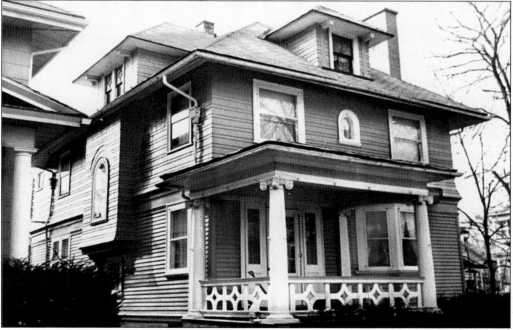

This well-proportioned American Foursquare was built at 29 Rugby Avenue for the Wilcox family around 1910. There were perhaps 2,000 Foursquares in the ward. Built for their practicality and affordability, they supplanted less-desirable older styles such as the "flashy" Victorians of 1870 to 1900. City promotions to develop tracts touted the ward's country feel of shady streets paved and lined with sidewalks and few streetcar tracks to endanger children. These promotions also advertised the absence of pollution, although the ward's sewers emptied into the Genesee River. (Courtesy Landmark Society of Western New York.)

Children enjoy playing in leaves on Rugby Avenue on a crisp autumn day in 1990. (Courtesy Rochester City Hall Photo Lab.)

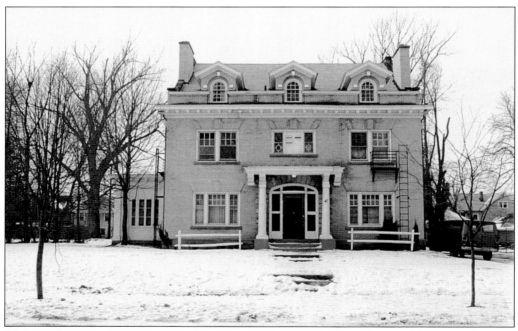

This residence at 47 Wellington Avenue provides a study in craftsmanship for students of architecture. It was built about 1907 for the family of Frank Taylor, president of the Union Trust Company. The neo-Georgian residence exhibits many fine details, including gables, dormers, dentil moldings, keystones, round arch windows, dormers set in a balustrade above the cornice, Palladian windows, an elliptical arched fanlight, and flanking fanlights.

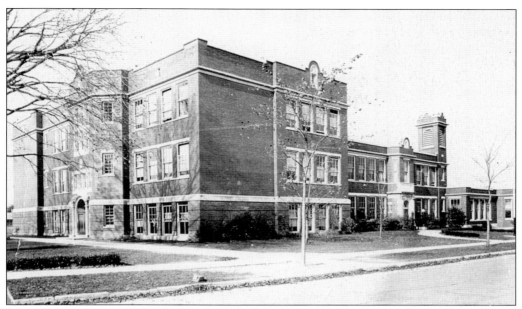

John Walton Spencer School No. 16 was built on Post Avenue in 1911. (Courtesy Rochester Public Library Local History Division.)

A March 1991 ice storm wrought havoc over much of upstate New York, leaving more than 250,000 homes and businesses without power. Neighbors begin removing fallen branches on Woodbine Avenue. In some parts of the county, homes were without power for weeks.

Patrick J. Mackey rescued this portion of the altar of St. Patrick's Church during its demolition in 1930. He positioned it in the backyard at 91–93 Congress Avenue and embellished his Memorial Shrine of Old St. Patrick's with fanciful woodwork, columns, and balustrades. (Courtesy JoAnn Bell-Isle.)

In 1914, Patrick J. Mackey took his wife, Agnes, for a walk along Congress Avenue. He had a shovel on his shoulder, and when he stopped at this lot, he told Agnes to turn over a few shovelfuls of dirt. He then told her had purchased the lot, at a time when there were only three or four homes in a country setting. Between 1914 and 1915, the Mackeys built this impressive duplex. Their granddaughter JoAnn Bell-Isle continues to live there.

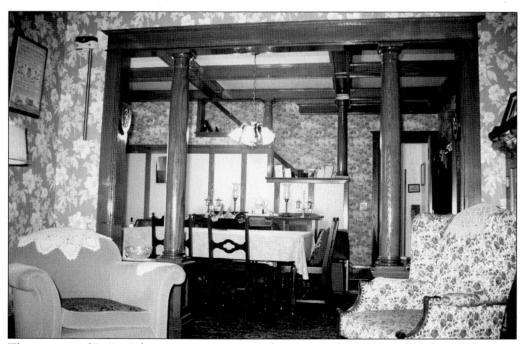

The interior of JoAnn's home remains unspoiled, retaining furniture and wallpaper from the 1940s and 1950s and light fixtures from the home's construction. Glistening columns and ceiling beams recall the days of unsurpassed craftsmanship.

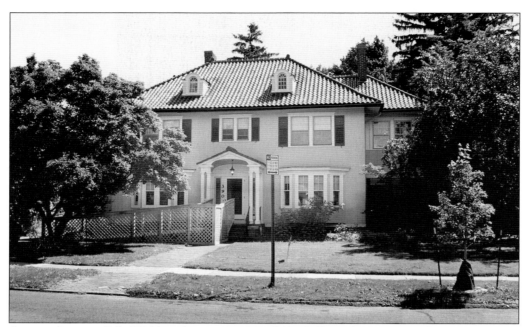

A site of many 19th Ward gatherings is Grandma Collins's home on Wellington Avenue. Grandma Collins, thought to be the matriarch of the ward, brought her sense of southern hospitality to New York. Regular soirees continue to be held here after her passing.

At Grandma Collins's soirees, women enjoyed fine conversation, music, delicious desserts, and drinks in the garden. In the tradition of this Southern entertainment, the ladies arrived wearing hats. (Courtesy Diane Bayer.)

It's All About Community

19th Ward Community Association

The 19th Ward Community Association's brochure shows Grandma Collins, a proud father with his daughter, and two young buddies mugging for the camera. The "oldest continually operating" neighborhood group in the country remains true to its mission "to create a conscious multi-racial community where individual and cultural differences are not only tolerated, but celebrated and where people share a sense of community." Efforts to diminish stigmas about the neighborhood continue. It has been said that there are more African Americans with doctorates here than anywhere else in the city. Only 6.4 percent of total police calls are from the 19th Ward, and a majority of renters looking to purchase homes prefer this neighborhood to others in the city. (Courtesy 19th Ward Community Association.)

Early residents lived an almost cloistered life, surrounded by peaceful residential streets. Of course, there was some snobbery, but an overall sense of pride kept the ward strong for the time when real social forces threatened it, starting in the 1950s. This streetscape captures an elegant neighborhood that, in spite of its knocks, refuses to surrender its dignity. (Courtesy Rochester City Hall Photo Lab.)

Students take time from planting flowers at Danforth Towers on West Avenue to pose for a group photograph. As parents and teachers continue to instill children with a sense of community, the community can be optimistic that the historic 19th Ward will remain vital.